Still Doing Life

22 LIFERS, 25 YEARS LATER

Still Doing Life

22 LIFERS, 25 YEARS LATER

Howard Zehr *and* **Barb Toews**

THE NEW PRESS

NEW YORK LONDON

Requests for permission to reproduce selections from this book should be
made through our website: https://thenewpress.com/contact.

Published in the United States by The New Press, New York, 2022
Distributed by Two Rivers Distribution

ISBN 978-1-62097-648-7 (hc)
ISBN 978-1-62097-721-7 (ebook)
CIP data is available

The New Press publishes books that promote and enrich public discussion and
understanding of the issues vital to our democracy and to a more equitable world.
These books are made possible by the enthusiasm of our readers; the support of a
committed group of donors, large and small; the collaboration of our many partners
in the independent media and the not-for-profit sector; booksellers, who often
hand-sell New Press books; librarians; and above all by our authors.

www.thenewpress.com

Book design and composition by Lovedog Studio
This book was set in Warnock Light

Printed in the United States of America

10 9 8 7 6 5 4 3 2 1

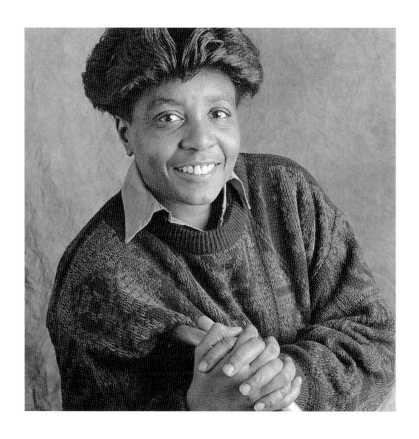

We dedicate this book to the memory of Sharon "Peachie" Wiggins, who died in 2013 while serving a life sentence. Originally sentenced to death for a crime she committed at seventeen, Peachie had her sentence commuted to life without parole in 1971. As is apparent from interviews in this book, she inspired and mentored many, leaving a legacy that continues today. Peachie was a participant in the phase of this project that began in the early 1990s, with an extensive interview featured in Doing Life.

Dr. Lance Couturier, former director of psychological
services for the Pennsylvania Department of Corrections,
had an essential role in envisioning and facilitating this project.
Without his encouragement and assistance, it never
would have happened. We regret that he did not
live to see its completion.

Contents

Introduction

We made a mistake, and it was a bad mistake! We can't erase that mistake and draw on the board again so it'll be alright. But what we can do is use that mistake to help others not make that mistake.

—Commer Glass

Don't let what you did, your crime, define who you are. If you let that define you, you're done. You'll never see the potential you have to become someone other than an inmate.

—Cyd Berger

Each night in the United States, more than 206,000 of the 1.5 million men and women incarcerated in state and federal prisons go to sleep with the reality that they may die without ever returning home.[1] The vast majority of these individuals are eligible for parole consideration at some point during their sentence, but more than 55,000 are serving life without the possibility of parole. Of these, 2,300 were children under the age of eighteen at the time of the crime for which they were convicted.[2] The only hope for release for those serving life without parole is clemency or a pardon from the governor of the state in which they are incarcerated or, in federal cases, the president. The rarity of these reprieves has contributed to this sentence being colloquially known as death by incarceration.

Despite dropping crime rates over the past several decades, life sentences have increased dramatically. Prior to 1970, only seven states had laws allowing for life sentences without the possibility of parole. By 2012, this number had grown to forty-nine states, Washington DC, and the federal government. In twenty-nine of these states and the federal government, life without parole is the *only* sentencing option for some criminal convictions, such as first-degree murder.[3] However, current criminal justice reform efforts suggest that support for life sentences is waning, and dialogues are being opened about the harmful experience

and consequences of life sentences for not only incarcerated individuals but also for survivors of violence and society at large.

What is it like to serve a life sentence? How does one cope, grow, and change as a person? Do life sentences bring about an experience of justice for survivors—does it attend to their needs and hold accountable the person who committed violence against them? Does incarcerating someone for life make society safer? Are there other ways to effectively achieve public safety and reduce harm without permanently removing someone from society?

This book invites you to explore questions like these in two ways. You will see the faces and hear the words of twenty-two women and men serving life sentences (known as "lifers") without the possibility of parole in Pennsylvania at two points during their incarceration, twenty-five years apart (early 1990s and 2017).[4] By taking a decades-long look at how these individuals have coped in prison, made sense of their lives, and grown as community members, we have an extraordinary opportunity to learn firsthand how aspects of their time spent incarcerated have stayed the same and have changed, for better or worse. These men and women also share their perspectives and opinions on criminal justice policies as they relate to life sentences, commutation, and other types of criminal justice reform. The interviews end with John Frederick Nole, released in 2019 and reinterviewed in 2021, who reflects on his life sentence from the comfort of home. Although the people depicted here are just a small fraction of the approximately 5,400 individuals serving life sentences without the possibility of parole in Pennsylvania, their emotions, challenges, triumphs, and journeys through life share similar themes.

A closing essay explores life sentences as both a unique human experience and public policy issue through the lens of trauma, race and racialized trauma, and restorative justice. This examination introduces the relationships among trauma, violent behavior, punishment, racism, and racial disparity in the criminal justice system. The essay ends with lessons we can learn from the men and women in this book about trauma healing, and also offers a vision for ways to achieve justice that do not rely on extreme sentences—ways that heal, rather than harm, those who have committed violence, survivors, and communities as a whole.

As authors and compilers of this book, we have clear opinions and concerns about life sentences as both policy and a form of justice, and their impact on the men and women who serve them. Nevertheless, our underlying goal in this book is to encourage dialogue rather than take a rigid position. In doing so, we also wish to humanize those who have committed violence and are serving life sentences. We hope that you will read and use this book in the same way.

The Portraits and Interviews

Howard Zehr

I first photographed and interviewed the men and women featured here in the early 1990s, which culminated in my 1996 book *Doing Life: Reflections of Men and Women Serving Life Sentences*. At the time, I received support and feedback from organizations working with lifers at Graterford Prison in Pennsylvania, as well as from the Pennsylvania Department of Corrections, and met with around seventy-five men and women serving life sentences in Pennsylvania prisons. The lifers were suggested to me by members of lifer organizations and sometimes prison staff or volunteers. I asked only that people interviewed be able to reflect on their situations and that they represent a variety of ethnicities, ages, and perspectives. As I said in *Doing Life*, I make no claims that this is a scientifically selected cross section of lifers; those who have been overwhelmed by their circumstances, who have not managed to mature and change for the better, are undoubtedly underrepresented.

As the years passed, I often thought about returning to do updated portraits and interviews with the people from *Doing Life*, to see how and what they were doing, but the Department of Corrections policy had changed and access was impossible. Then in 2017 the former director of psychological services for the Pennsylvania Department of Corrections, Lance Couturier, encouraged me to try again. With his help, I received permission to repeat the project on a smaller scale. In 2017, twenty-five years after the first visit, Lance and I revisited two dozen of the women and men from *Doing Life*, selected to create a fair representation of the original group.

My purpose in these documentary projects was and is to encourage a genuine dialogue about justice. So much of our discussion on crime and wrongdoing is based on labels and stereotypes. By allowing people to present themselves to us, without visual cues that trigger stereotypes, I hope to encourage a dialogue

about real people, real ideas. Too often, the way people are presented encourages us to see them as "other" than us. I wanted to reduce "othering" and encourage human connections.

As a society, we have predetermined ideas about people in prison, which are often triggered and reinforced by archetypical prison photographs and the unilateral way people are shown. I set out to avoid these visual "cues" by photographing people with a neutral background, respectfully, as I would want to be portrayed. In the early sessions, lifers were allowed to have a set of "street clothes" in their cells and wear them on special occasions, including the photo sessions. That policy has changed, however, so in the 2017 portraits they are wearing prison garb. They are also seated in roughly the same pose as in the original photo, looking directly into the camera and inviting the reader to look back at them.

Acknowledging Our Bias and Language

Barb Toews and Howard Zehr

If our portraits were in this book, you would see that we are both white, of European descent. We acknowledge that we have benefited from a society that values white people over Black, Indigenous, and people of color (BIPOC); these benefits extend to socioeconomic status, educational achievements, and experience with violence and the justice system, to name a few. Who we are ultimately shapes how we understand what the lifers have shared with us and how we share it with you. The men and women featured here have trusted us with their images and stories. We have taken great care to see and listen well, recognizing the limits of our own bias. As you read, we encourage you to also consider how who *you* are influences how you understand who *they* are.

We are also aware of how labels can dehumanize people and reduce them to a single identity. "Offenders" are more than just people who offend, and "victims" are more than just people who have been harmed. "Lifers" are more than just people serving a life sentence. One person can be all these things at once, in addition to being a mother or father, a teacher, an artist, a writer, and more. Especially in this book, where the closing essay will discuss the ways in which victimization can lead to harmful behavior, labels fail to capture a complex experience. Even naming harmful behavior as a "crime" or an "offense" is a form of reductionism; these are labels that the criminal justice system has applied to such behavior and, as we will suggest in the concluding chapter, can distract us from the underlying harm caused by the perpetrator and the responsibility to repair. Choosing what language to use can be tricky, as there is no agreement among those impacted about what words and labels are best to use. While we do use these labels on occasion, we have used a variety of language and phrases to make clear what particular experience we are referring to.

Still Doing Life

Kimerly Joynes

You have to come to a point where you believe goodness feels better than the pain you have endured

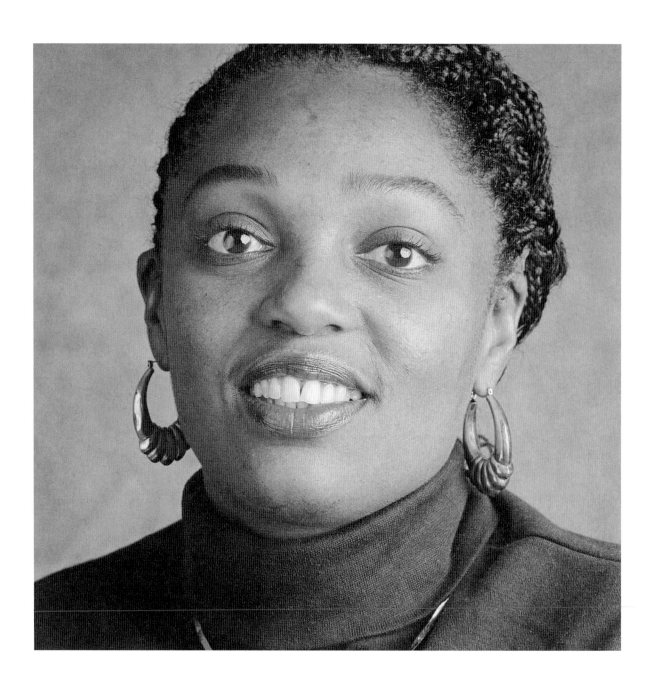

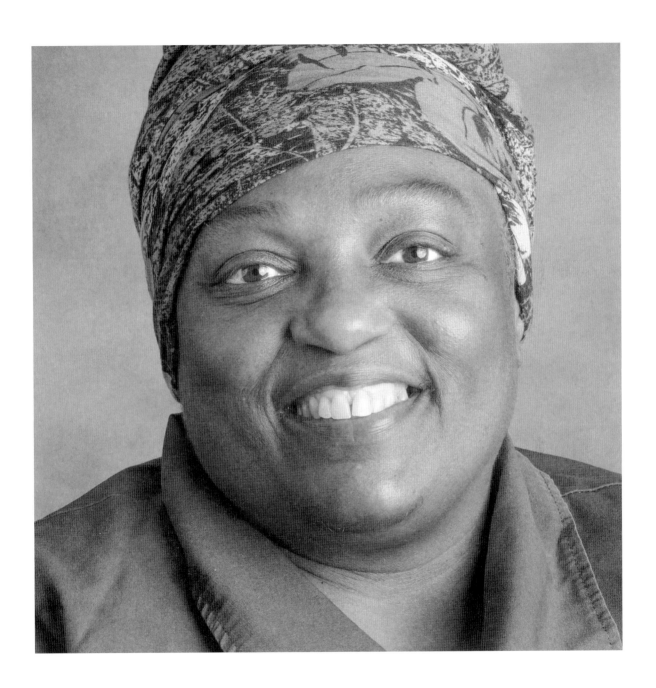

Early 1990s

A life sentence is like being on the outer regions of the outer limits, a voyage into the deepest part of negativity you could ever imagine. It's a black hole of pain and anxiety that you must learn to overcome through spirituality.

Prisoners help each other rehabilitate themselves. It's a fantasy that you're going to come to an institution and they're going to help you with your problems. If we don't help ourselves, we won't get any help.

People, even staff members, forget you are a person. They might have a bad day, yell and scream, or lie about a situation, or talk to you like an animal in a zoo. You have to psych yourself up just to mind your business and keep going. When you understand your overseers and the mentality of your peers, you learn to take a deep breath, pray, and find new ways of communication and approaching a situation. You learn when to speak out and when not to, be it right or wrong. Another lifer recently told me how she had been demoralized. She was crying and I held her, and it took everything I had to not snap and scream at the top of my lungs. I closed my eyes and gave her my advice: call your family, take a deep breath, write all the events down.

One officer did take a great interest in me and I really appreciated it. She kept me in line. She would say things to me: "Be mindful of your surroundings and be mindful of yourself." "You have a little common sense, use it." She would ask, "How's it going today?" "Did you read anything interesting?" "Did you learn anything today?" I would wonder what she was talking about. One day I was so angry, I went to maximum security and she said, "You took your mind off yourself." Then it dawned on me what she meant. From that day on, I started really looking around me and my whole perspective changed.

I'm different than the person who came in here. I have a great deal of patience and tolerance. I'm even-keeled, soft-spoken. I'm not as loud and boisterous. I communicate more, listen better, and am slower to respond. I take one day at a time and keep myself focused on what I'm doing. Helping somebody else takes the focus off the hardship and reality of being here. It's painful and time-consuming, but I have my quiet time where I can pray and meditate. You also have to keep a sense of humor because

there are days when you fall down on your knees screaming and crying.

The young people need to know that it is to their advantage to get some education. It's not hip or fun to be illiterate or chasing the new fad drug or apparel. Money is better when it's earned and not from sticking somebody up.

When I was sentenced, my judge literally believed that after seven years it was possible I would be paroled. I'm up for commutation now. This is the second time. They don't give us too much information about what the commutation board is looking for, other than institutional achievements. Sixty percent of my application is my institutional record. About 40 percent of it is me, personally. But in that record, they see a lot of who I am because I bring myself into my work.

I received my associate's degree to be a paralegal, but it worked against me because I was considered a troublemaker or manipulator for helping people with misconduct cases. It's a contradiction, because people on the outside say, "Exercise your education," but it's resented in here. I am an auto mechanic apprentice now. I like learning new things, but I took this course because I've done everything. There's nothing else for me to do.

I hope people will get beyond the stereotypes they have of us. We are not living well in here and have just as many problems as people in free society. The only difference is that we have no choice in our responsibility. I would rather be in a free society earning my keep than be patronized and told what to do on a daily basis. That's not part of rehabilitation.

You have to show that you can be responsible for yourself. I walk freely to and from where I have to go. The movement is controlled but when I'm in, they know I'm in. I could be away from the officer for two or three hours and she knows I'm where I'm supposed to be. I don't have any problems and I intend to keep it that way. It helps when someone trusts you.

2017

This year will be thirty-eight years inside. I had just turned nineteen when I went to trial. In the last twenty-five years, my life has been a successful spiritual journey. I've attained peace through self-disclosure, motivation, understanding, and living with integrity, even inside a situation where it's 99.9 percent negative. I've accomplished things that have helped me become the best me. I don't have anything to brag about, I just enjoy my life. The worst part about it is that I can't utilize my accomplishments on the outside.

A combination of things helped me on this journey—life and death, the loss of family, living my realities. Life doesn't change whether you are on the inside or the outside, so I had to make some conscious decisions about how I wanted to live my life while I was incarcerated and earn a legacy

for myself and my family. What could I do while I'm living so somebody could say something good about me when I pass over? I started going back to school, earning certificates, reaching out to people. I changed the way I think, look at people, get involved politically, and deal with my support systems. I've learned about law, the hierarchy of our society, and how they look at me as a throwaway, not a human being. Continual prayer and faith also play a part in my change. I ask God to renew my heart and keep me open to the things that I don't feel good about.

Before I focused on myself, I was going through a lot of turmoil, anger, and resentments. I wanted to look at myself but I would fall back until it was everybody else's fault. I was just yelling, kicking, and saying, "Why? Why? Why?" Today, I know why: it was the choices I made, the people I hung around, the lifestyle I led. It cost me thirty-eight years of my life in prison. Turning around was gradual. I didn't want to give up my old behaviors, my old stinkin' thinkin'. I wanted a crutch to hold on to. There are so many people who help us to help ourselves, so I didn't want to be negligent and not do the best I can for myself and for people in the same or less fortunate situation as me.

I help the younger women a lot. They're torn, abused, molested. They've been psychologically raped, physically raped. Most of them are addicts, some of them had abusive childhoods. They suffer hardships, some I can identify with and others I've never experienced. It's heart-wrenching. I listen and extend compassion and comfort to help them realize that there's more joy than hardship. You have to come to a point in your life where you believe goodness feels better than the pain you have endured.

I work as a Peer Assistant in the drug and alcohol unit, and in the evenings I work as a Certified Peer Specialist (CPS). As a CPS, I go around to the units and talk to people to make sure they have everything they're supposed to and check how they're feeling. Some of them cry because they are so embarrassed. Some say they don't care, but they do and are ashamed. I don't have any problem crying with the clients because I'm the same as them. Whatever the emotion, I don't get up until they feel fulfilled. It's a slow process, but they start to feel better about themselves. I need the CPS program in a lot of ways, so it helps me stay focused.

Taking time out for myself is very important because I need rest. Sometimes I have to pray to God to give me the understanding and fortitude to deal with situations that are bigger and heavier than me. He helps me out, and I'll dive right in and it's successful.

Doing a life sentence is good and bad at the same time. The good part is the joy I receive from helping myself and others. The bad part is the negativity and the emotional, psychological, and spiritual crushing that comes with living in a penal colony. It's so easy to fall prey to the negativity that you

have to fight with every fiber of your being to be constructive and stay focused.

At the time of my trial, nobody cared enough to find out about my background, where I came from, what I'd been through, or that I was pregnant with my first child. All they knew was that somebody was going to pay the price. Now, the mindset is changing and they are trying to help people who have the same background as me. But people from my time are holding on, fighting the good fight to get out of prison.

My case is in superior court because I have put in a post-conviction relief appeal. It's taken four years to find the jurisdiction that could hear my case, but that's how the law is; it wants you to give up. I never gave up. Hopefully the next time I see you, it will be, "Hey, here's a postcard. I finally made it."

Charles Diggs

*Hope, the echo in my brain,
keeps me stimulated*

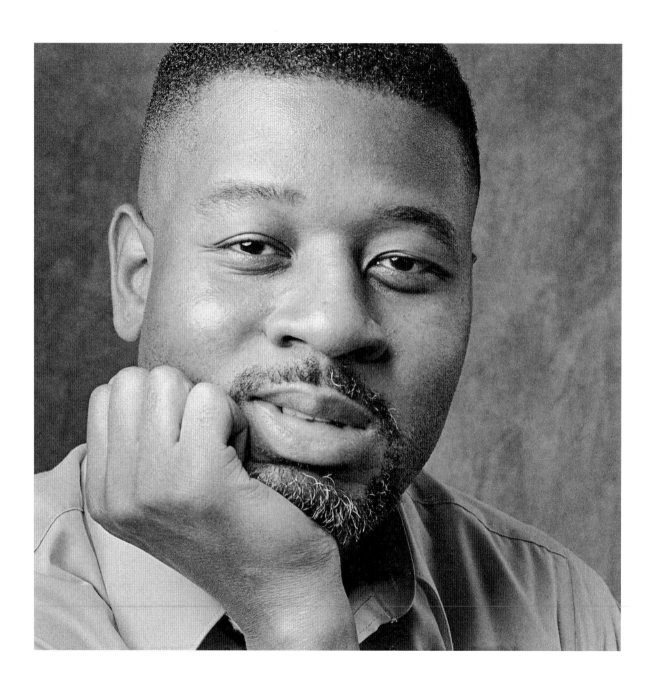

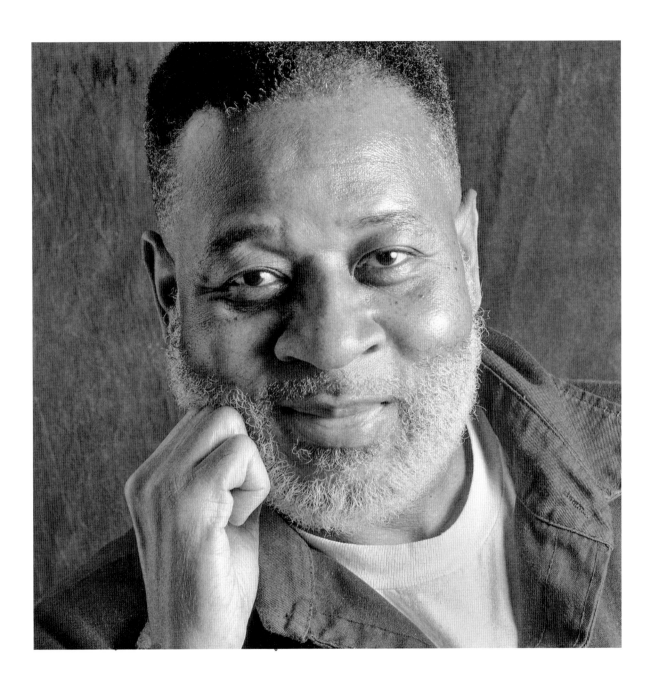

Early 1990s

It's an ongoing struggle every day to try to make something out of nothing. It picks at you, piece by piece. It involves a lot of sadness; it's a stressful situation. It takes a toll on the family. You see things chipping away slowly but surely, and that tears you to pieces. It picks you apart.

You may have some community and family, but you need more than that to really keep you all together. You got to have something greater than yourself that gives you hope to get up each day and perform like a sane human being, and not what you have been labeled to be: some vicious killer.

What a guy's in jail for probably only took a few seconds. That's not the whole person. That's just a couple of minutes out of the person's life. There are more dimensions to that person. I think we're wasting thousands and thousands of people by just writing them off as no good.

The district attorneys like to give African American men all-white juries. In my trials, they always struck the African Americans and Hispanics from the jury. In my original trial, about twelve African Americans were struck. In my second, around eighteen were struck. In the third and final trial, about fifteen were struck.

Everyone thinks you are guilty and that you deserve the treatment you are getting. "Do the crime, serve the time." They avoid the issue of the level of guilt or innocence. The crime may not be first- or second-degree murder, which carries life without parole; it may be third-degree, which doesn't. No one seems to care that the prosecutor overcharges you, and you can rarely bring in the mitigating circumstances that would make it a lesser degree. Also, the prosecutor has so much power with witnesses. Us young men who came to jail at a young age got the full force of the so-called law and came up with these life sentences.

With good reason, people in the African American community are afraid of the police and the system, and look to them as the enemy, as oppressors. I wish that the Creator would make creation over and make everybody one nationality, one race, one language. There would be less suffering and tragedies that aren't being dealt with.

Sometimes there is good news in here. Someone gets a new trial. Or a guy may share that his daughter had a wedding or

that he has a grandson or granddaughter. Or some guy's graduated from school, gotten his GED. That makes my day brighter. Or I get a card. Then we might have a good meal. We'll talk about it and laugh.

You'd be surprised. It's a community here, and there's enough mature men that they make the days go by. They make the day constructive. They talk, they gossip, they complain to one another.

At 9:00 p.m., though, when we go into lockup, that is the worst. I am probably the most miserable person when I go into my cell. I'm reminded that I'm locked up.

You see a lot of masks on the men, administration, guards, and even on your own families. I've studied the different masks, and I know how to deal with the guys. I've got little masks on, too. But I don't hide it. I speak about it and I try to get guys to talk. I've found guys who got stuff bottled up. I know they're suffering the same thing I'm suffering. I've gotten a lot of guys to open up.

A lot of funny things happen here. A guy patted a female guard on the butt, and she slapped him, knocked him down. I'll never forget it. She handled things real perfect! Or a guy snaps out in his cell, burns everything up, runs down the tier with nothing on. That would be the talk of the jail.

2017

I've been here forty-two years. I was twenty-five years old when I was arrested and I'm sixty-six now. Life keeps moving on and I'm still pursuing my freedom and innocence. My faith and hope are what's keeping me alive.

I still have a sense of humor, even with all of the tragedies. I still have the values I got from my parents. I am learning more about my religion, Islam. I'm getting a deeper understanding of myself and human beings. I understand the government and our country more because I am challenging the state government for keeping me in prison. I study law, and I consider myself a lawyer; you get a good eye on what you are dealing with.

It has been difficult living in an environment with 3,500 men. Traveling through that each day is a test. It's a struggle seeing your friends pass away and people who have diminishing mental faculties around you. You have to be very cognizant of how delicate things are to avoid conflict. I think we do an excellent job of tolerating one another.

Lifers play a mentor role to the younger guys. Lifers still run many different programs, and the guys respect that. But I do think lifers should respect the younger guys more. People say to the younger generation, "do this" and "do that," but my generation had our style, too. We wore our pants, talked, sang, and danced a certain way. A lot of the younger guys weren't raised by fathers. Most are hungry for the older guys to tell them something right and not negative, but they may not know how to say

it. They call me "Mr. Diggs, old head." It makes me feel like I am valuable.

My brother, who had more time in than me, said that wherever you're at, you can be important and positive. I always carried that. You have to make a life for yourself here, make the best of it. I have a few friends who are pessimistic and everything is doomsday. I make U-turns when I see them. That attitude is not healthy.

It is hard to keep family connected to you. You see family slipping away. Family members move. The old die and, if you're not close-knit, the younger people's visits drop off. I feel like they don't care about me, but I say to myself, "They don't even know me. They don't owe me anything." You have to understand, maintain, and not get bitter. People struggle trying to make it, but I've gotten over that. The guards who came in with us are retired. You give the new ones a little history and stay away from those who are fools.

Someone new facing a life sentence should stay positive. Work on your legal matters, get all the education you can, and keep your health up. That keeps you busy so you don't worry. The worrying can cause you so much pain and you can't do anything else. Some people get medication for the pain and just go to sleep, but I found that, through time, things heal and solve themselves in a way.

People want to have hope about commutation. You don't need false hopes, though. You need reality. It's about self-awareness. Maintain your own humanity, regardless of how things may turn out in the end. You got to live each day the best you can. The guys call me "Bad News Charlie" because I'm straight up with it. You can't deal with your problems unless you face them.

My faith helps me keep hope. I don't believe that God is punishing me. Life deals you a hand and you have to play it out. My dad always said, "Get all the education you can and you'll make it out of there eventually." Hope, the echo in my brain, keeps me stimulated.

I was president of the professional law clinic for twelve years, until they closed us down. Now I work on the block, doing a couple of cases here and there to help guys. I lend my legal books out. I'm working on my case with my lawyers. I keep busy with that, the lifers' situation, the Gray Panthers, and Inside Out organizations.

A life sentence is a form of suffocation. Slowly, you're trying to gain some oxygen so you can come alive again. I'm not getting the amount of air that I really need, but I get enough to sustain.

I've learned that life is very precious. All life should be honored. It's a gift.

Craig
Datesman

*Meeting with the victim's family
was the best thing*

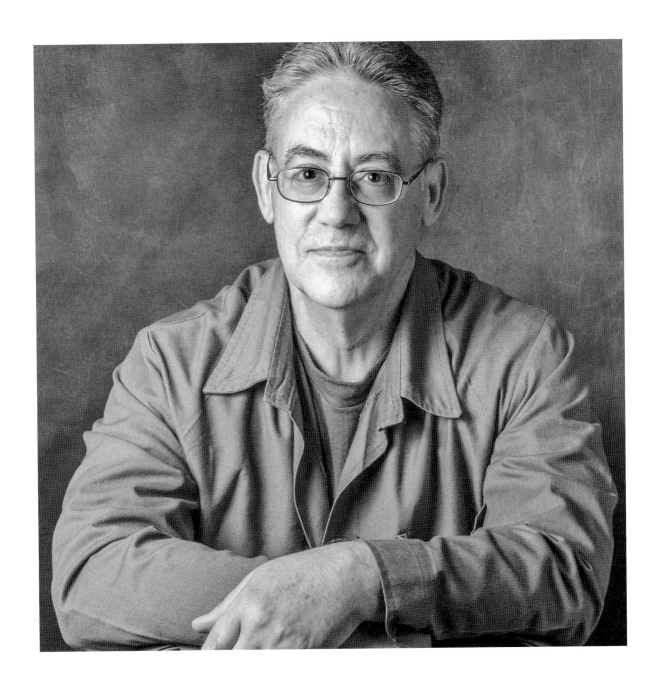

Early 1990s

A life sentence is daily frustration, like being a factory worker who does menial tasks and knows he's never going to get promoted. At least outside you have interpersonal relationships to break it up and experience new thoughts and relationships. In here, you feel like a robot because of the control you're under. You have to shower and eat at the same time every day. If you have a job, you have to leave and return to the block at the same time. Day after day, week after week, and then year after year. Nothing breaks it up at all. The only day that's different is Sunday because I usually have a visit.

The music program is very, very important to me. I played a little saxophone and keyboard on the street. I took it up again in here. It's a stress reliever. I'm fortunate enough to have a keyboard in my cell and I close the cell door and just play. I write music, too.

My one wish is to be free, or at least to have the conviction overturned. I would be happy to have been convicted of what I'm guilty of, and I should have taken the plea deal they offered me. I find the dichotomy of plea bargaining very disheartening. On one hand, a district attorney can look at you and the circumstances of your crime and offer you a third-degree murder charge, making you eligible for parole in ten to twenty years. On the other hand, if you don't take their deal, they can try you for the death penalty. That just doesn't jive.

All you're doing is dying every day. When I'm sixty, I don't want to be paroled to a retirement home with my family gone. What's the sense of living? I can only do so much in here. I can help. I tutor people in literacy. I'm involved with the youth-at-risk program, trying to make a difference out in the community with a letter writing project. This semester I'll graduate with my associate's degree. But it seems fruitless because I have no way to apply it.

Deep down inside, I try to tell myself that there might be a reason or purpose for all of this. I look for real and little things from day to day. It's funny how little they become. Every couple of weeks, we can have a cheesesteak. Then you'll plan for a musical performance a couple of months from now. A special television program that's coming up in a week. Just look for real little things.

I don't laugh too much, but when I do I

treasure it. I get amused sometimes by people and how they react under certain circumstances. Or how adamant they get in arguments over politics or religion.

The one thing I really miss besides family and children is not sex, but the ability to love, to share your life with someone else. That gives you reason to live. Here you're doing it vicariously through letters and phone calls.

2017

I'll be sixty-four in June. I'm working on thirty-five years inside now and I'm taking it one day at a time. I realize how much faith and hope I had in the system twenty-five years ago because I still had appeals in. When all appeals are dead, you start looking for something else to keep you going. It's a challenge keeping hope alive. Now I'm at the commutation stage. When I went up in 2014, I had good support, even the full support of the victim's family. But it was right at the cusp of the gubernatorial election, and I only got one vote after the merit review hearing. I'm trying again in a year. I'm hopeful.

I could have taken a deal. They offered me a deal for third-degree, and the attorney said, "Third-degree is probably the most that you're going to be convicted of anyway, so why take the deal? It's up to you!" This was right when they were picking the jury. I could have had a ten- to twenty-year sentence and maxed out fifteen years ago. That pulls at me.

I had no real interaction with the criminal justice system at all before, so I didn't have any kind of understanding of what it was. Even my victim's sister said that the district attorney told her, "He's got a life sentence but he'll be out in seventeen years." After twenty years and I'm still not out, she started wondering why. Then another sister contacted the apology bank where we had sent the letters to through the Victim-Offender Reconciliation Program, and she looked me up on the internet and saw articles I had written.

The meeting with the victim's family, telling her what actually happened, was the best thing in my whole incarceration. She told me what the loss meant to her and was understanding of what it's done to me, and how I've changed and grown. It's rewarding to know that, even after thirty-five years, they aren't hating you, being vindictive or wishing you were dead. They're on my visitors list, send letters and cards, and have written letters for my commutation. I did a TEDx talk about it in Graterford. The reconciliation program was really rewarding. It was funny how the fruits of something that you did ten years ago come back so much later. It just kept growing.

A life sentence is death by incarceration, different from having the death penalty where you know you are going to get it on a certain date. Here, you're just sentenced to die while you're living here. You really

struggle to find meaning in life and get through, day by day. The meaning of life is fleeting and fickle.

It's all what you make of it. Meaning right now is my job. I love computer programming; I love everything about it. I keep busy. I take part in programs like the Alternatives to Violence Project and the Lifers' Organization.[1] I finished my associate's degree. I worked in the dental lab for five years and thirty years in the Correctional Industries office. Programs like the reconciliation program and photography class give guys hope and a reason to get up or look forward. Once you get to a point where you're not doing anything, it gets a little melancholy. You can't sit around and do nothing.

Everybody is anxious about the move from Graterford to Phoenix, the new prison.[2] For all thirty-five years in, I never had a cellie, but at the new prison we're moving to, every cell is a double. I'm hoping they'll let us choose our guys, and I'll move in with an eighty-two-year-old friend. I just want somebody who wants to be left alone. It's going to be a drastic change.

I've grown a little bit more realistic as far as how tough the system is, no matter what your issues are in court. I realize how important family is and how satisfying it is to help others—tutoring other people, being there, sharing your experiences with them. It's more satisfying than constantly worrying about yourself and what you're going to do next or accomplish. I think that comes with maturity.

Marilyn Dobrolenski

*Getting through one day
at a time*

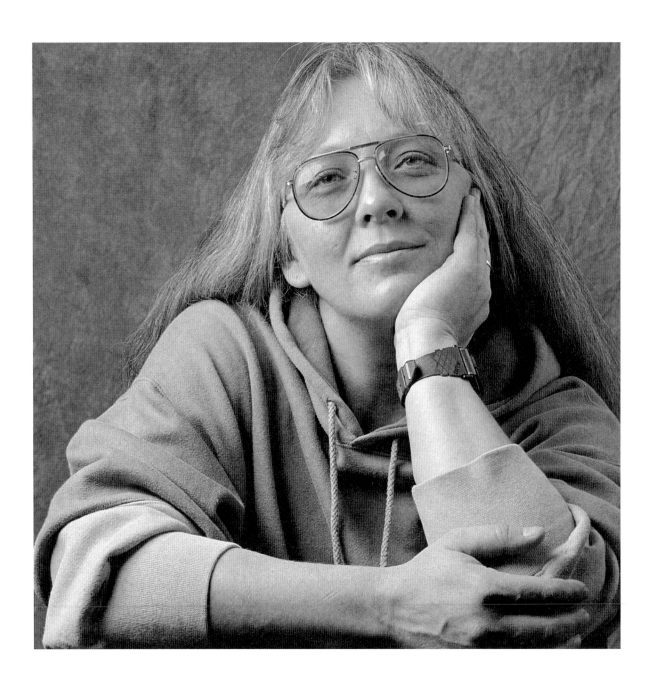

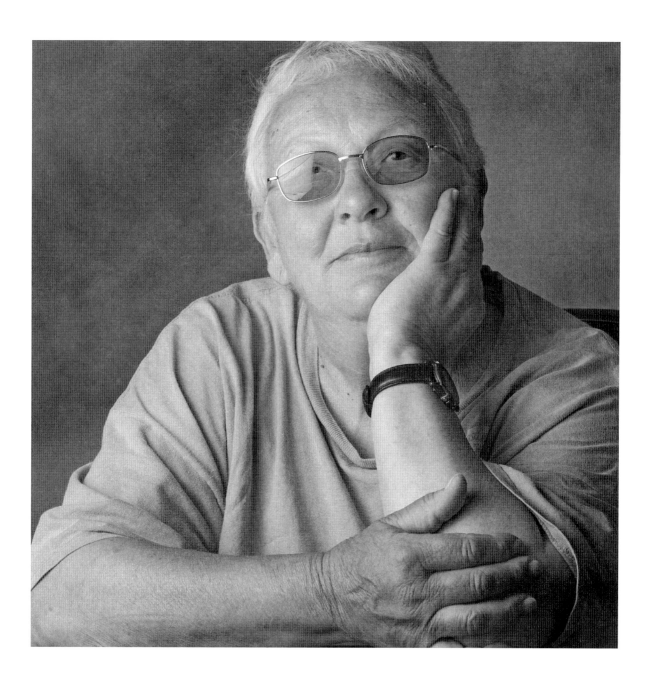

Early 1990s

The hardest thing about a life sentence is being away from my family. My relatives are getting older. My daughter was only two and a half years old when I came to prison. She's twenty-three now. She's grown, and I missed her entire childhood.

The other thing that's been hard is that I now know who I am, and I know that I've become a responsible person. I'm a very talented person. I don't mind saying that I feel I'm being stifled in here. I'm hung in the balance between trying to overcome the limitations of the prison environment and trying to adapt to them.

I've been here the second longest of any woman in this prison. When I came here originally, I had the death penalty. Three days after I received it, the U.S. Supreme Court abolished the death penalty in *Furman v. Georgia*. It took approximately a year for the courts to take me back and resentence me. In the meantime, I went through a roller-coaster ride, because the district attorneys used mine as a test case to keep the death penalty. I was in and out of court, and it was a ball of confusion. I was a confused young lady to begin with, without

the stress of facing that trauma, and I was basically alone.

The process of finding out who I am was gradual. I spent a lot of time at first in solitary confinement, and I got into reading my Bible. I began asking, "How did I end up here?" I had a lot of emotional dirt from my childhood and young adulthood to wash off in order to really get down to ask, "Who am I?" It took a few years to realize that I don't have to let people lead me around and that I'm capable of making rational decisions.

People think that rehabilitation means the system has succeeded in their program to rehabilitate you. Their programs cannot rehabilitate; you have to rehabilitate yourself. There are women who have been here almost as long as I have who are no further ahead than the day they stepped in. There are others who are a true success story. These women chose to grow and to rehabilitate themselves, to make their lives not only suitable for the outside, but very suitable for living in prison.

About three years ago, I became a welder in the maintenance department. I love this kind of work, and I spend most of my summers outside. I spend almost all my free time painting. This past year, since I've

been out of college, I've been bombarded with commissions for artwork, and I love it. I wish I would have pursued this in high school. Even as a child, I was fascinated with art. And I was a nature lover; I grew up on a farm. If they ever say, "Dobe, you can leave here tomorrow," that's what I would be looking for—a place in the country, a farm perhaps, where I could get back to doing the things that I should have been doing twenty-two years ago.

A life sentence is like fishing. The river looks calm and you forget to drop anchor. You don't realize that your boat has started to drift into the rapids. Then you get stuck in a whirlpool. You get sucked under and then come back to the surface. Other people go by and they miss it, but you're stuck in that whirlpool. Just about the time you think you're able to break free of it, the water sucks you right back down.

2017

I am now the woman in Pennsylvania who has been in the longest, since Sharon Wiggins died. Forty-five years, since '72. McDonald's wasn't even open for breakfast. The Vietnam War was still going on.

I'm getting old. After my welding boss retired, I went into plumbing for ten years. Then I ended up working in the upholstery shop, doing wood refinishing, for close to ten years. When that boss retired, I went to the activities department to work. I'm try-

ing to slow down because being a workaholic has put a lot of wear and tear on me.

Painting is my job detail now. I'm part of the Mural Arts project. Before I started that, I'd already been doing some paintings around the institution. Most of the paintings hanging in the staff dining room are ones I did. I was selling some on the outside and even in here. We used to have a yearly craft show, but I was selling all year long. The money I made off it kept me in art supplies. We can't have oils in here anymore. I almost gave up, because I had painted with oils for years, and acrylic paint is a whole different ball game. It took some practice until I learned to manipulate it so the paintings come out the way I want them to.

I've been busy with the dog program for fourteen years now, since it started. It gives you a chance to give back to the community and see what these dogs do for the people they're with. Plus, it's a lot of fun to have a dog around you all the time and to see them learn. You can almost see when the light bulb goes off in their head. We usually get the puppies when they're between eight and ten weeks old, and they are a lot of work, like having a toddler. They get big quick, and it's not easy to give them up. It's bittersweet because you're giving up a dog you just spent a year of your life with but, by the same token, we usually get another puppy the same day so we're too busy to dwell on it. We hear about how some of the dogs are doing. One guy who has a seizure alert dog sends Christmas cards because he's so

appreciative of the Muncy prison puppy program. Once the puppy I have now is gone, I'm going to see about being an alternate, and be a grandmother to them. They come visit, and when I've had my puppy fix they can go back to the younger women who are training them!

I'm less tolerant now of some of the nonsense in here. And there is more nonsense than there used to be. Some of the kids come in here and think they own the world. I'm sure when we were kids we probably did too, but I don't know if we were quite as obnoxious. Some older lifers try to mentor them but some of the girls don't want to listen. You can talk until you're blue in the face, but they think they know it all. So you try to tell them, especially the young ones coming in with life, "You might not want to get involved with what you're about to do because it's going to create havoc for you. You'll spend years trying to live that down." Every now and then, some will take what you're saying to heart.

My priority now is getting out. Since I had just turned nineteen when the crime happened and I got convicted, I've had a couple of petitions to be released because I was sentenced to life as a juvenile. I understand that there are lawyers in Philadelphia who are trying to see about getting the eighteen- to twenty-year-old crowd released, and I think my name is on the list for this bunch. Before I put my commutation papers in, I want to try to have it resolved this way first.

I had given up hope of ever getting out.

Now, Governor Wolf has been pushing people to get their paperwork in, even though it's taking three or four years to go through the whole process. I said, "My God, by the time we get the paperwork in, he might not be governor anymore. We might be back to square one." I'm trying not to get my hopes up just to have them let down again, because at my age, sixty-five, that would not go over very well.

I lost my mother last year. My dad is still around. My daughter tries to come down twice a year. Since they've lowered the phone rates, I'm able to talk to my brother and sister on a weekly basis, finally. I went for almost twenty, thirty years without having much contact with them because calling my parents and daughter sucked up a big chunk of change. I'm done with the ink pen and writing—the pen slips through my hand, my hand starts cramping after five minutes, and I'm like, "I'm not writing all these letters!" I try to send cards, and by the time I sign the card and fill out the envelope, I'm done. I email, which makes it so much easier.

I've seen so many lifers in here die, either from old age or from other illnesses. Even if I am here until I die, I'm going to try to make my life as easy as I possibly can, within the parameters of what I have to deal with. That's why I do the dog program. And with the painting, I'm at a job where I can set my own pace. I get through one day at a time and do what I'm comfortable with.

I'm engaged to a guy I've known for close

to thirty years. Last year, we started talking about getting married and said, "Why not?" I have the dates, and I've found out what times we can actually do it on those dates. He will talk to the clerk at the courthouse to set up a time for a videoconference, because I can't go out there to sign the certificate. He used to live down in Delaware County, and he'd come up once a month to visit. I finally asked him what he thought about moving to this area. Then, lo and behold, he moved here, and he's glad he made the move. He said "If it wasn't for you, I wouldn't have a motorcycle, I wouldn't have the dog, and I wouldn't be living in a nice community." So it's beneficial for both of us.

Commer Glass

This is our community,
but it's not our home

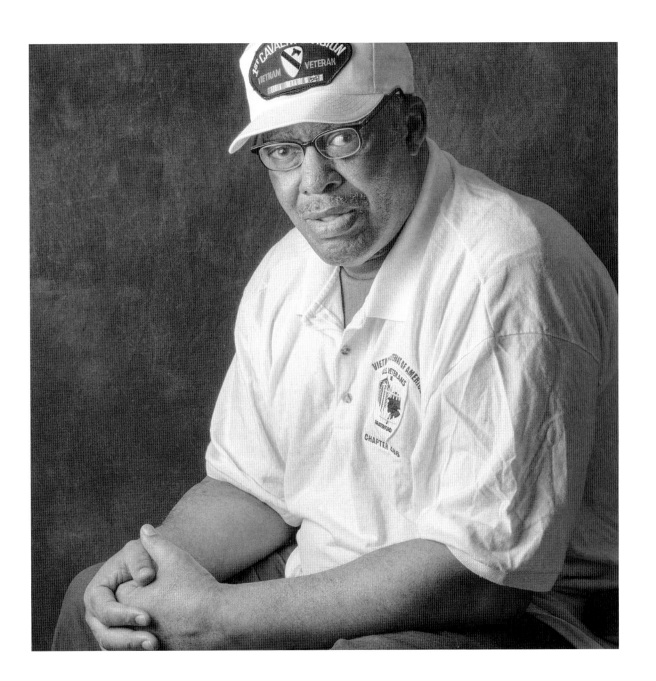

Early 1990s

The biggest part of my life is being a veteran—I'm head of the veterans right now. No less than 25 percent of the lifers here are Vietnam veterans, combat veterans. Many are suffering from PTSD—post-traumatic stress disorder.

A lifer has to keep his stamina, keep up his awareness and mental capacity. And try to hold on to his family, if he has one. That's a lot of pressure; it's a continuous struggle. You never know if you're going to make it.

What's most frightening about a life sentence is knowing I've acquired the capabilities and the knowledge to be somebody, to be a productive citizen, to be able to help others not get caught up in the situation—but I'm not able to really get out and help. I see our communities dying. I see our families breaking up. And I know that I have something to give.

This is my community right now. I'm living here. I have to try to make this a better place to live. I have to try to make this a better place for you to come into. And the only way I can do that is by being real, honest, and truthful—not only with you but with myself.

We are willing to take it upon ourselves to try to better the community so that others won't follow in our footsteps. I would like society to take a good look at human beings and know that changes can be made, that changes are made by a lot of human beings who are doing life. There are a lot of good people sitting in these penitentiaries who are needed outside.

It's like going deep-sea diving, going all the way down into the depths and losing your oxygen. You're struggling to get to the top. You don't know if you're going to make it, but you never stop struggling.

2017

It's been forty-one years since I came in. A lot has happened, and a lot has stayed the same. I'm still on that mission to try to help veterans get that second chance at life. It's in my blood. It seems to be working since the Afghanistan and Iraqi veterans have started to come in here. People seem to gravitate to them, but they still forget about the Vietnam veterans. So the fight and mission is still there. We want people to see that we fought for this country, and a lot of things

happened to us. Without taking away from the crime, we're asking that you give us a second chance. That's what I'm going to keep fighting for.

I've gotten an education, two associate's degrees and a bachelor's degree. God has given me wisdom and knowledge. He's given me strength. I'm still swimming toward that light. It flickers and gets dim sometimes, but lately it's been getting a little brighter. I remember the scripture, Isaiah 40:29, where he says, "If you believe, I will renew your strength, and you will run, not get weary, you will walk and not get tired, and you will mount up on wings and fly like eagles." That's what I'm holding on to to keep me going. There are times that you just want to quit and give up. I'm not a quitter, and I can't give up. We've got too many things we need to do. I try to help people around me to keep swimming towards that light. The generation that's coming in here now doesn't have a clue, so we got to teach them about life, to appreciate different things and how to be knowledgeable, and that they can live and have choices. Truly, it's about them now.

When I was in the service, the man that stood next to you was your brother, your friend. He was you. For the new generation, I don't think the man that stood next to them was them. Whenever I lost my friend in my squad, I lost a part of me. We had camaraderie. We fought hard, didn't give up, and we got something done that still reverberates through the system now.

Society is backing the new generation of vets because of us. They have what they call Veteran Service Units at different penitentiaries. We don't have one. We do our jobs and take care of the whole population anyway.

I've become a Peer Support Specialist. They didn't want me because I was blind, but I made them give me a chance to prove myself. I came out second in the class! That certification will be good for me to help veterans and young adults out in the street, which is what I want to do. Tell them my story and help vets overcome their PTSD. It might never leave, but you can deal with it, turn it around, and flip it. We still have guilt because we came home. We couldn't help our brothers when they got killed. We feel shame for some of the things that we did, the atrocities. That pushes our PTSD, but we can flip it. They gave us what I call the "bloodstained banner." They put their lives on our shoulders and now it's up to us to do the right thing to help, to carry them with us everywhere we go. Then you can halfway deal with the guilt. You deal with the shame by saying, "I know that it was wrong, but I did it because I was asked to do it, not because I actually wanted to do it. Now let me help others because of the lives that I might have taken. Let me help others to see that they can make a life, that they have choices in life." This even goes for my case. I feel remorse. I carry that big bag on my shoulders, but I don't mind because that's what pushes me. Youngsters say, "Hey Mr.

Glass, I understand how you feel. I understand what's going on now. Maybe I can change my life around."

I get a lot of meaning out of helping veterans and other people. I used the Peer Support to begin a group where we talk about responsibility to yourself. Changing yourself. Respecting yourself. Not harming yourself. That's the way you are able to be truly responsible for the things that you do. The guys start to open up. Some of them start crying, because they want to change.

This is my community, and we have to deal with it like it's our community. It's not our home. We have to make it as good and as straight as possible. We have a lot of things on our back. A man has to try to keep his family together. He has to keep his mind and self together. He has to help and keep people around him together. That's what the community does. If one is weak in an area, and one is strong in an area, then the strong helps the weak. We can't leave nobody behind. I don't want to see anybody doing life giving up. If you give up, that means you fail. And we're not failures. We made a mistake, and it was bad mistake! We can't erase that mistake and draw on the board again so it'll be alright. What we can do is use that mistake to help others not make that mistake. And we have to do it as a community. The old saying goes, "Each one teach one." That's what we have to do.

I'm no superman, no real smart guy, nothing like that. All I do is say, "I care for you all, man." I failed by coming out of the military and not doing what I was supposed to do, not carrying that bloodstained banner. Now, I have a second chance to grab that banner and hold it high, even though I'm in the penitentiary.

Every little step forward is a success. My goals are to be able to help people, mostly to be involved with a halfway house, a house for second chances. I see success when I get a letter from a guy's wife or mother that says, "Thank you for helping my son." Success is seeing somebody get something out of what you're doing. I'm down, as long as I can help somebody.

When I get out, my whole scenario of my life is this: I'm going to go to Coatesville, put a cap on the PTSD, and learn all that I don't know. I want to learn.

Brian Wallace

I always believed
I was getting out—I just
didn't know when

Early 1990s

I came into the prison system when I was fourteen years old. I'm thirty-five now. I was tried as an adult because it was a capital offense, a homicide robbery. I had two co-defendants; one was eighteen, the other was thirteen. We were tried separately and they were found not guilty. I was found guilty. My lawyer said he would appeal my case, but I found out three years later he never did. Later, a judge granted a motion for a new trial under the Post-Conviction Relief Act and it went to the federal court but was denied. So now I'm thinking about going up for commutation.

It's a struggle when you're young. You're coming into a state correction institution with grown men. You're trying to find your way, to feel your way through the environment. You're hoping and praying that one eventful day you'll gain your freedom. At the same time, you're trying to place yourself around people who foster your growth.

I've changed tremendously since I got here because I matured from a youth into a young man. I found things out about myself and things about life that I'm totally amazed at. Now I continue to learn and to grow an appreciation for life.

You gain a sense of understanding and you accept that you're here. It's hard. But nobody said life was going to be easy. You just strive and struggle to gain your freedom. And you want to try to do all you can to elevate and enhance yourself to be a better, more effective person when you get out.

Unfortunately, all my family members have passed since I've been incarcerated. But I have a female in my life who's a good friend of mine. And I have two godchildren and I see them regularly. That's a blessing.

I don't favor life without parole because I think anyone can change. To say a person made a mistake and then lock them up for the rest of their life is inhumane. Actually, I would describe a life sentence as a death sentence. There's a good possibility that you will never get out. You're living every day and wondering, "Is this going to be permanent or temporary?" You hope that it's temporary because you're working toward your freedom. But when they say "life sentence" they take away a man's hope, and when you take away his hope, what else does he have? All I can do is hope and pray and remain striving in the way of the good.

It's like you're climbing up a hill and wondering, "Where's the end? Where's the peak?" You're striving to do everything you can to add to your credits but it feels like that's still not enough.

Lifers do a tremendous amount of good in this institution, but it seems like it's not recognized. When a negative act or incident takes place in here, it's magnified to the highest level. But when something of a positive nature is done in here, it seems like it isn't covered in the media. The perception of people in society is that people in jail are all bad. They're dangerous. They need to be in there. What about people who have made amends, who are well worthy of a second chance?

2017

I just turned sixty in February. Life is still good.

In January, I got resentenced to a forty-years-to-life sentence, and I went to see the parole board in May. Now I'm waiting to see the outcome. I always believed I was getting out—I just didn't know when. But I never thought it would be this long. My grandmother used to always tell me, "You just keep hanging in there," so I always kept that in mind. I kept getting involved in programs and school. I was instrumental in initiating a lot of things. Now I'm looking forward to walking the challenges of life outside. I'll go to work, go to school, slowly enter a rela-

tionship, get to know some family members who weren't even born when I was around. Like my nieces—they got children, too.

I couldn't have done it without the help of God. I know I couldn't have done it on my own. I have a lot of strength but I think my strength comes from the Creator.

I've been incarcerated forty-six years and in this institution for forty. I came in Sept 23, 1971. I was stupid and irresponsible and I made my life what it is. It will never happen again, by the help of God. I've tried to do so much to put it behind me, but it's something that you can never forget, because it is part of your life. But you have to focus and do some good things where you feel respected. I think I've done a pretty good job with that. I'm more mature and responsible now. I think now I'm more equipped for anticipating and taking on life's challenges.

I tried to get in touch with the victim's family a couple of times. When I went down for sentencing in January, the victim's family said that they were moving on with their life and they were not going to oppose me. I spoke to them indirectly when I had an opportunity to speak in front of the judge, but it's unfortunate they weren't there because I had prayed all these years for the opportunity to speak to them and let them see the person I am today. But I felt good getting that out.

I'm in a program here called FACT (Fathers and Children Together) and it unites fathers with their children. I see that as a way of giving back and doing some

good. I don't have any biological children myself, but I see the need for keeping the father in a child's life. My father did some time, and when I was on trial in 1972 he got killed. I see that commitment as really being important. I'm going to stick with it on the street.

With a life sentence you get a sense of unendingness. You've got to find a way to keep yourself alive mentally. Sometimes you experience falling into ruts, and it's hard to restart again. It's like you wake up and say, "What's the incentive for me going to school when I'm never getting out anyway?" You have to work to improve your situation, and have hope at the same time, so that when things do change, you can seize that opportunity. Hopelessness is a dark place to be in.

I worked up in the administrative suite and I could look straight out the front. I told a friend, "One day I'm going to walk right out of here, watch." Then when I got approved for my outside clearance, I started going out the gate and down to the dairy to work. I said, "Next stop, I'm going home." It's funny how things can happen. It's like one thing sets it up for the next.

I don't think adjustment will be a problem for me when I get out. I have some people who are going to help me transition. I've been praying for help to make my transition smooth and I've prepared for years, doing and learning different things. I got the first thing in mind: I'll say to my nephew in the car, "Give me the phone. I want to call a few people." I already told my sister and nephew what my first meal is going to be: red salmon and rice. I got a niece who's making a sweet potato pie. And the first thing I'm going to buy is a milkshake. I've been thinking about a milkshake for thirty years!

Twenty-five years ago, I was still fighting for my freedom. Now twenty-five years later, I'm going to see my freedom. God is good!

———————

Brian was released from prison a few weeks after this interview took place. His release was the result of Supreme Court decisions in 2012 and 2016 that ruled against mandatory life sentences for those sentenced as youth.

Marie Scott

You aren't the only one being punished—your family is too

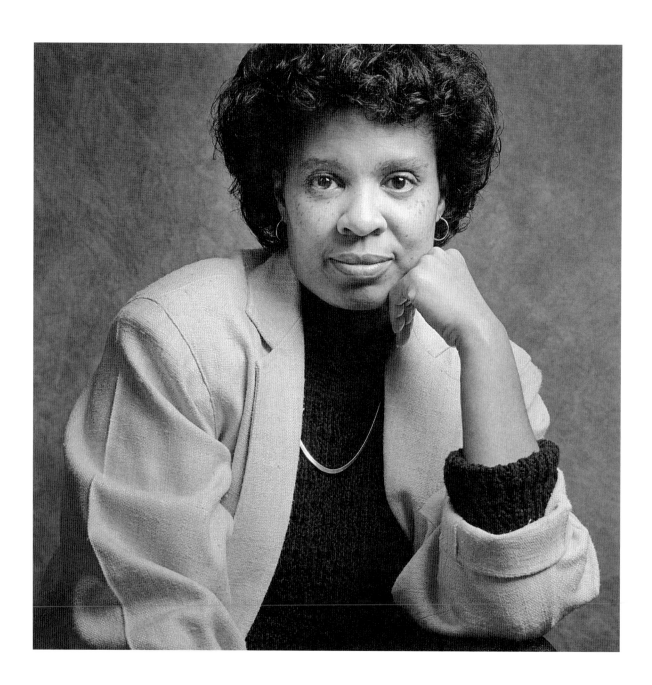

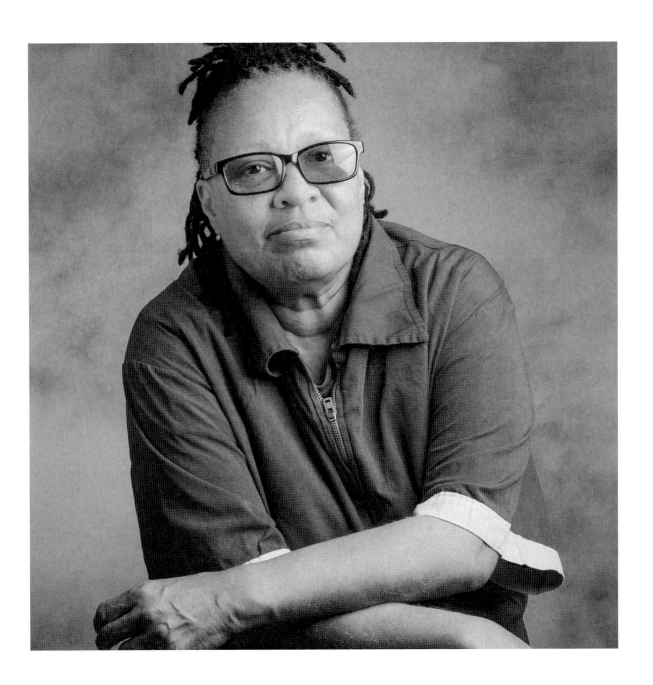

Early 1990s

Since I can't seem to get myself out, maybe I can stop my daughter from coming in. I didn't get a chance to do that with my son. He was four when I came here, and he's in prison now, and that just tears me up. I can't imagine sitting here in Muncy with my daughter! I don't want that, so I'm doing everything I can to help children get the aid they need to prevent them from coming here.

Right now, the main thing that is keeping me going is a task force that I'm trying to start called Children of Incarcerated Women. One day I hope to see a support group in schools for the children of incarcerated parents. That's who is going to be filling up tomorrow's prisons if we don't do something. They're psychologically messed up because of the separation from their parents, and nobody is paying attention to that. We have advocacy groups for the people we victimize directly, but those groups don't cover the victims who are forgotten about—our children.

I'm being punished for something I did, but I'm not being allowed to try to do something about it—help my victim's family.

That's the most frustrating part about a life sentence, because I do have a conscience.

There was a time when I had a problem with going up for commutation because I didn't feel as if I had the right to ask for a second chance. Did I really deserve that second chance, no matter what I did to better myself? I can't bring this man back. I spent three years going through that, and then I started finding other ways to give back since I can't give them his life back. I try to do best by my fellow man and my fellow sister, and I can't do any more than that.

I had nightmares when I was a child, because I was sexually and physically abused. Sometimes I'd wake up and couldn't tell the nightmares from reality. A life sentence is like that. I go to sleep wishing it wasn't true, but when I wake up, it's not just a nightmare. It's reality. The hardest thing is not knowing when it's going to finally be over or if it's ever going to be over.

I look up to Sharon Wiggins, another lifer. She's my idol here. If they ever let her out, I pretty much know I'm going to get out. I know what she's built in here, and I've always tried to follow that, to build the same thing. I know in my heart that when God's ready to let me out, he's going to let me out.

God knows the circumstances of my crime and how I feel about it. If he's a forgiving God, then I'll be out of here. I could be one hundred years old, but I'll be out of here.

They got a whole lot of lifers that they need to let out. Lifers could be an asset on the street because lifers know what it's like to be out there. They are wasting the taxpayers' money. They're wasting a lot of good minds. I could talk to children and tell them what it's like to drop out of school and get involved with drugs, because I've been there before. If you can give a child any kind of experience, it'll help more than telling them they shouldn't do something.

When my judge said I would spend the rest of my natural life in prison, I freaked because I didn't understand what that meant; my lawyer had told me that I'd be out in seven years. Then when I got here and they told me I was never getting out, I couldn't deal with that. Had we understood that, my lawyer probably would have used different tactics in my whole trial.

I know that if I had been in my normal frame of mind, the murder wouldn't have happened. I took something I thought was a sedative and it wasn't, but it was my choice to take it. It is horrifying to me that I was in a situation that resulted in somebody's life being taken. I had never so much as stolen anything, let alone killed somebody. I came into jail as a kid, nineteen years old. In prison, you got to try to play hard, and a lot of things I wound up saying made me look like I was tough when I really wasn't.

Women don't stand much of a chance at getting commutation, compared to men. We're blocked from avenues that lead to male lifers being recommended for commutation. We're told that we cannot be in a supervisory position over other inmates, so even though I'm trying to get a degree in a helping profession, I can't help out as an assistant with any diagnostic group. We can't even go to the honor cottage and stay.[1] Only eight lifers are allowed there, and they can only stay for two years before they're put back out in general population. We can't even be situated anywhere we can get our roots dug in to try to get some peace of mind. If we can't do these things, the board can't even consider us.

2017

I'm working on my forty-fifth year now.

When Peachie (Sharon Wiggins) died, it seemed like the world knew it. She was so phenomenal—all of the things that she achieved and was doing for all of the other inmates. We lost our minds. That was the first time that security staff ever let inmates go from one unit to another, and they were coming in droves to sit with those of us who lived in the unit with her, and then I went to other units to try to help out.

My co-defendant was recently resentenced to forty-three-to-life because he was a juvenile at the time of the crime and should be released by now. I found out that

my victim's surviving children were at the hearing. I guess my co-defendant was going on and on about getting a bachelor's degree in prison. The daughter had said, "Wow, you know, I can't even afford to send my son to college." That hit me like a ton of bricks. It never dawned on me that the pain reached that far, that it would stop their education. I'm now asking for Pennsylvania to conduct a study on the problems and needs of children whose parents are murdered.

I was the first peer facilitator for the YAO, Young Adult Offenders. I never saw so many children in pain. One of the YAOs took her life because she was being bullied. That just crushed me. I was so angry about that happening that I wrote a play and named it *Just Stop It*. I put it on with some of the youngest kids with behavioral issues. There were tears at times, but they did a heck of a job.

When I lost my son, I lost it completely. But until that happened, I could only have sympathy for my victims because I'd never lost anyone that I loved. They lost their father, brother, and son, and I'd never had that happen, in prison or in the street, because I never really had someone to love me until I had my children. A couple of months after my son died, it hit me that this is what they went through. No wonder they are so mad and hurt! I want them to know how truly sorry I really am. I'd like to do a victim-offender mediation so I can offer them the chance to say whatever they want to say to me.

I've learned to draw from another woman here. I've done a lot of portraits and got real good at it. I remember when I was just trying to learn, I had to hurry up and do one. Peachie knew that I couldn't draw, and when she saw me drawing, she said, "I really didn't believe in God but I really believe it now! Because I know you couldn't draw and now you up there drawing!" She was just floored by it.

It is so difficult with the younger generation! They are so disrespectful that it just turns you off from mentoring them. Those of us who used to do it are too old or worn-out from doing it for so many years. But it would be nice if this prison could have space for one-on-one mentoring, like we used to, to get them on some kind of track that will lead them out of here and not come back. I peer facilitated in the Wings of Life program, and I still get letters, ten to fifteen years later, that say, "You helped me do this and because of that I'm who I am today." That's the reward, right there.

I'm hoping that the bill in the legislature that gives the chance for parole after a certain number of years gets enough support to get passed. That will give me a chance at parole. The superior court is hearing my case because I was sentenced to life with parole but there is no life with parole in Pennsylvania. I'm not sitting around just saying, "Oh well, this is it." This will never be my home.

A life sentence is a slow death by incarceration. You have this hope dangling in

front of you that maybe one day you'll get out. I don't understand what it is that I have to do to get a merit hearing. I'm not asking the board to let me out—just hear me out. That's what the merit hearing is for—to at least hear what I have to say and then judge whether I'm worthy of release. No woman has gotten a hearing since 1989. You can't get mad and sue them, you're just told to be quiet and wait. If it wasn't for a friend on the outside, Ellen Melchiondo, who helps us with commutation applications, women serving life would be hidden in the shadows.

Not a lot of women serving life get visits. Family just falls off eventually. They're doing the same time you're doing, and I think there just comes a time when they can't do it any-more. And rather than telling us that, they just disconnect. You'll be excited about getting a visit and family doesn't show up. Then you're told, "Something happened but we will be up again." You're excited about the second visit, and it doesn't happen, again. Eventually your coping mechanisms kick in, and then you realize, "Okay, this is the way it's going to be." I'd rather it be this gradual way because it winds me down with disappointment little by little, and I just get to the point where I can deal with it. It was hard for me to realize that my daughter wasn't going to visit me, but the more you do time, the more you understand what it's really doing to your family. You're not the only one that's being punished—they are too.

Ricardo Mercado

People care—you just have to cross paths with them

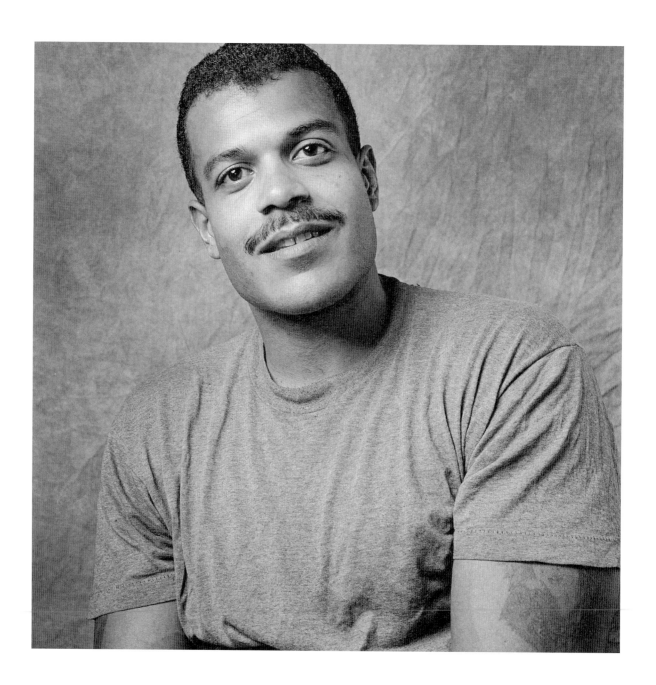

Early 1990s

People think that this is the belly of the beast. But you'd be surprised. There are some positive individuals in here, some really empowering individuals who are not criminals. By an accident, a freak of nature, they ended up here. And there are some smart individuals, caring individuals who could be good role models and leaders in society. They are leaders of organizations in here. Most of them are lifers.

There are guys who take time to reach back and pull somebody in and say, "Look, you can do better." At first you're like, "You're jiving me." But seriously and relentlessly, they keep on you. Finally you see there must be something to this. Then when you associate yourself with them, you see that you'd rather be with this crew. There are a lot of them in here.

At first when I came in, I was lost. It was such a big place that I didn't know what to do. They saw me, the quiet guy, and said, "We ought to talk to him and get him involved." They approached me and that's how it started. Now I've got to remember what they did for me and pass on the dollar.

I do volunteer work to give away what I've learned. It's gratifying to see somebody who used to play cards on the block seven days a week get away from that card table, which is doing nothing but pacifying them, and get involved in school and programs.

You have to believe that if nothing happens the way you want it to, it's not because of any wrongdoing on your part. You have to be strong enough to continue trying to make a change. Hope is something that you can't get from somebody else. You can't read about it and pick it up. It's got to come from within.

It's not easy, though, because I'm not Superman. I'm tired of this. I want to go home. The reality is that I can't. So I continue. Besides, there are people like Tyrone, president of the Lifers' Organization.* I've seen him go out and get an award. I've seen him in street clothes. Those kinds of things do give you hope, not only for him but for me.

A couple of months ago a guy was stabbed in the corridor, in the jugular vein. I have a homicide conviction, but I've never

*Tyrone Werts, who was included in *Doing Life*, was granted commutation and released in 2011.

seen that. I guess it shows that people commit some acts in a blind rage, and we don't know what we've done. Standing at the window and watching him get it in the neck and spinning around with blood gushing out until he fell on the floor—I will never forget that look. It made me realize what it was that I did. I'd seen somebody else do it, and it shocked me. I still see the kid's face. I still see the blood coming out. It made a difference to me. It said to me, "This is what you did."

It happened in front of our office where I work, and the accountant wouldn't open the door to save the kid. Paranoia set in, and he didn't know what to do. It goes to show that some who are in positions of authority, with keys to the door, panic themselves.

Commutation is a paper shuffling, red tape thing. And it doesn't work. If you don't have a relative or know somebody who knows somebody in a public office or the system, you stand zero chance of getting out. We stand a better chance if we were able to face the board so I can see them and they can ask me questions about my past and my case and everything that I've done in between. Now, they judge me on a twelve-year-old record and make a decision based on paperwork from people I've never met, who wrote things about me that may not be true.

I've learned that what you do always affects somebody, even yourself. I've learned integrity and how I had none. I've learned how to accept responsibility for my actions.

I've forgiven myself for what I did because I understand who I was when I did that. It hurts thinking about what I did. You often just want to set it aside. But in order to go forward, you got to remember where you came from. I don't want to ever land in that same position again.

Life in prison is like being in a large room where you can't feel the walls. It is dark, pitch black. You don't see the light. Everyone talks about it, but you don't see it.

2017

Just recently, a light has been turned on in that dark tunnel that I shared earlier. There are many more deserving people than I, who have accomplished far more than I have in my thirty-seven years inside, who should be given a chance to get out before that light leaves.

I grabbed onto one side of that dark tunnel and I've never let go of that side. I didn't bounce to the other side or look the other way. I'm paving my own way. I was eighteen years old when I met prison superintendent Vaughn. He wanted to keep an eye on me. He made me sit in a chair in his office and said, "Do everything that you can and do it with the utmost integrity." Every day I learned from him. We will never see anybody else like him. He cared.

I'm a huge fan of Hannah Arendt. On page 241 of her book, *The Human Condition*, she writes that the alternative to forgiveness,

though by no means the opposite, is punishment. What they both have in common is that they can go on endlessly without the interference of the other. She goes on to say that in the realm of human affairs, mankind is caught up in punishing what turns out to be unforgiveable. The system does believe in punishing, but the system also believes in giving people certain opportunities. Now, as a more mature person, I want to be grateful for the advice an officer gave me to not allow my emotions to take charge. I'm very much aware of that now. If I would have known what I now know when I was eighteen, I would never have done what I did—destroyed too many lives. It was unnecessary, it was reckless, it was thoughtless.

To go forward, you have to also see stuff that's going on in society. Stuff that's happening now never happened in the neighborhood that I grew up in. The blatant disrespect of people—carjackings, home invasions, or robberies in broad daylight—brazen things. Even though I committed a crime and was sent to prison for the rest of my life, I am truly grateful for the upbringing that I received from my grandparents, in terms of respecting people's space. There's a lack of that upbringing now. To these young kids coming in here, we're in the way. We're dinosaurs. I'm almost fearful stepping out there. But, once we get them in here, we try to point them in the right direction, for those who want to change their lives.

For eighteen years I've been judiciary secretary of the Lifers' Organization. You learn that people do have hearts, and people are willing to forgive.

It broke a lot of people's hearts when they changed from majority vote of the commutation board to unanimous. It really destroyed Julius.* But you can't be cynical or hold grudges. You can't be mad at the system for what you did.

There were individuals who used to walk this corridor, look at people, and say, "Come down to see me, I want to talk to you about something." Unheard of now. Father Finnigan was like that. He was a volunteer back in the '80s, and he'd walk on the block and go look for you. In my first class with him, everything went over my head. I didn't go to the second class, and he came looking for me. That was embarrassing, and I didn't miss a class after that. Unbeknownst to me, they were recruiting us younger kids to learn transformational thinking and empowering us to become lead facilitators for the class. Then Father Finnigan said, "I'm not coming in next Tuesday. Have Mercado teach the class." It forces you to the front, taking everything that you learned and throwing it out there. It was very rewarding because it changed my life. I know what my purpose is in here, in terms of helping somebody else.

We don't find that care and concern about people's health and well-being any-

*Julius Schulman, who was included in *Doing Life*, took his own life rather than endure a life sentence.

more. It's sad. Earlier, if I were being seen by a psychologist, they would say, "Mr. Mercado, this is what I recommend. Continue doing this. Try your best to stay away from that." Now they don't give A or B. They just absorb whatever you tell them, and then they write these reports. So it creates an "us against them" mentality. Who wants to be caught up in that? The system has changed. This place has changed, will continue to change, and when we go to a new prison, will probably change again. But what I've learned is that you can't change. Stay the course. You can't give up.

To cope, you have to keep hope alive. You have to have faith and believe that everything that happens happens for a reason. And you got to have goals, short- and long-term. When you reach the short-term goal, make another and you will reach the long term. It's constantly moving forward.

I have a wonderful support team. My primary support team is a retired Philadel-phia police officer who I met when I was working in the Family Resource Center in the visiting room. She had this unique ability to accept you for who you are and not judge you. To this day, she's still in touch. She changed my life. She came into my life for a purpose: to direct me, help me see things. I told her to take the civil service test and she came back the following week and said she signed up to take it. The following week, she said, "I'm going to be a Philadelphia police officer." She retired in 2017, after twenty-two years, well-decorated. Several volunteers also stay in touch. They always said, "If you ever need to talk to someone, come see me. My door's always open." I'm fortunate to have people like that. We don't have that no more.

People care. You just have to cross paths with them. My sister. My family in Florida.

I'm going to survive prison time, then go to Florida and get Zika from a mosquito bite!

Betty
Heron

*I've always felt like a
tightrope walker*

Early 1990s

My oldest granddaughter, little Meighan, precious child that she is, says, "Ma-maw, you have such a big house. Can I sleep over?" She doesn't realize what she is saying. This is okay when she is three or four, but what am I going to say when she's six or seven? I told my daughter, "I just don't want to lie to her." I want to always tell the truth.

I used to *do* life but now I live life. I know that I must make the best of the circumstances that I dealt myself. But it's time I expand beyond these fences of steel and stone that have served their purposes. It's now time to think about returning and saying, "I want to be one of the few that make it out." I want to be part of that number, and that's what I'm working toward. Commutation is an arduous process, but I still hope. As long as I have that, I will keep going. But if you talk about getting out of here, I must make a difference where I am planted.

When I came here, I didn't think there was anything wrong with me, but with everybody else. It was David who beat me; it was Tony who killed him. I was a conspirator, and it was always someone else's fault. I know today that I'm a far better person than I was. Now I understand not the *excuses* for why it happened, but *why* it happened. It makes me able to accept my blame and not use someone else as a scapegoat.

I know what I allowed with my codependent actions, my need for someone else, my fear of abandonment, the fear that I couldn't make it on my own. Now I don't think there's much I can't do on my own. Today I'm a healed individual. I'm more understanding and compassionate, but not to the point of letting someone use me again. I'm a supportive individual, but there's a limit to my being able to give beyond my boundaries. Before, I didn't know I had boundaries.

I remember the first question the psychologist asked. He said, "How's Betty?" and I said, "Betty who?" I was always Mrs. Heron—somebody's sister, somebody's mother, somebody's wife. Betty was not there. I did not have an identity. It was frightening when he reminded me later of what I had said. It gives me hope to see where I am now. I just hope that I can convince the Board of Pardons that there are redeeming qualities in this woman.

I suffer a great deal from what happened and my actions that caused my imprison-

ment. I'm ashamed, I'm humiliated, but responsible and remorseful; it's a horrible thing to be a part of. You have to be careful, finding a balance between morbid introspection and reality. Mea culpa, mea culpa—you can really beat yourself up. You need to be able to say, "What did I learn from this?" and take it into your reality.

When I first came in, I was led to believe that I was going to get out. I didn't know what a life sentence meant. I was never told. I thought, I have a life sentence, but that's what, seven years, ten years? But in Pennsylvania, a life sentence is forever. That was quite an awakening! It's complete deprivation, it's complete loss of freedom, it's complete loss of family life.

I've watched my family marry on videotape. That was hard. My name wasn't even on the invitation of the last child. I asked my son why and his answer was, "Because you weren't there when I needed you." I can't argue with him, but it hurts.

I believe I've been forgiven by my God and myself, but it's the forgiveness of the family of the victim and my family that's the problem. I'm deprived of the opportunity to face them. If locking me up for the rest of my life would bring my victim back, I would understand. But that's not the case. Justice without mercy isn't justice. I needed to be punished, but I need mercy to be fully restored.

A life sentence is like a glass bottle. You're planted in this foreign soil, this cultural abyss. They want you to grow, but in growing, if you aren't careful, you begin to take the shape and form of your environment. One of my proudest accomplishments is that I have managed to grow without taking the shape of my environment.

2017

I remember saying years ago, "I've watched my children grow up in photos and my grandchildren grow up in photos." Now, it's my great-grandchildren growing up in photos. Family is the anchor of my life. I'm still fortunate enough to have them supporting me and loving me, and seeing me when they can—though it isn't as often as we would like. The kiosk, email, and tablet have really helped me stay in touch with them. Their love strengthens me.

In the last twenty-five years I've grown a lot mentally and emotionally, though less so physically. I've had a hip replacement and now a pacemaker. I'm blessed to still be able to function physically and mentally. For about two years, I was in a wheelchair and I thought, "I can't do this." You don't have a lot of independence here, so I fought against being dependent even more. It took a long time, but they finally scheduled the surgery. I've learned to live in the moment, to not look so far ahead or behind me at something I cannot change. Living in the moment is also preparing me for the future.

I've always felt like a tightrope walker, because if you lean too far to the right with

hope, you're going to be disappointed, and if you lean to the left with despair, you're even worse. I'm not balanced every day, but most days I'm pretty balanced. And if the time comes to put in my application for commutation, I'd be right there ready. But if not, I'll make the most of what I have.

In 2002 we got our first service dogs to train. For the next ten years I raised about twelve dogs, until I got my hip replacement. I still keep my hand in it. Sometimes I take them to church with me, especially when they get older. The puppies are a little too quick for me! I can't tell you what a difference a dog makes in your life! Oh my gosh, I miss them so much, even though they are across the hall now, and they'll let one come over to the room sometimes. I love to be around them. They are so loving and unconditionally accepting. They don't ask me why I'm here.

I can take change if it's positive change. When it becomes negative, it's awfully hard to go backwards. It's gotten harder to do time. You look at the earlier photos, you actually feel human, wearing non-prison clothes. The only thing left in this bastion of identity is being able to do your hair or do something like that. The rest is gone.

There's an underlying anger that seems to permeate this place. When I see things that happen, I think, "Uh-oh, I better check myself," because I don't want to go around with that anger. It's a waste of time.

They say the older people should mentor, but you can't mentor people who don't want to be mentored. They're very content to be where they are. It's a different generation, and it's hard to communicate with them and really have a relationship. When you live with six people in a room, and most of them are younger than your children, and some are the age of your grandchildren, there's not a whole lot in common. There are pleasantries and you keep it light, but there's no depth. When you go to express something, they don't get it.

One thing that has kept me going is the realization that my crime does not define who I am. I did a horrendous thing. Believe me, every day when I look in the mirror, I know that. But I've changed and would never allow that to happen again. I have self-esteem now; I have inner strength. I am not my crime. I've developed by being positive in my thoughts, actions, and deeds. My faith sustains me. I am where I am today because of my faith.

I often think about what I said last time about a life sentence as a glass bottle. I did not take the shape of my environment. I am still able to rise above. There is the strength of a weed that grows up from the cement; it's a weed but it's growing strong. I think of myself that way. A lot of weakness comes from not feeling good about yourself. I have enough self-esteem about myself to know who I am. I'm a mother, a grandmother, a great-grandmother. And most of all, a survivor.

Bruce Norris

I've learned that no matter where you are, you always have to give back

Early 1990s

For me, the most frightening thought is dying in prison. I put a lot of emphasis on being able to die on the street with some dignity. I don't mind dying. I just don't want to die in prison.

What keeps me going is that I'm pretty secure in myself. I don't have any problems in prison. It's just a matter of trying to do the best I can. I don't even think about how much time I've done already. I can't get away from it, but I don't dwell on it.

I try to do positive things and keep myself busy. I play and coach basketball. I'm the first referee for the volleyball program here, and I play. I've gotten my associate's degree and am one semester away from getting my bachelor's degree. I work in an accounting office. I like to talk to young people. I have a guy, twenty-two years old, who just came in and he's adopted me as his father. I try to guide him in the things that he's going to need to get through this bit. So far, he's done a pretty good job of helping himself and that gives me a lot of pride. I'm involved in community programs such as Youth at Risk, and the Girl Scout cookie sale. I sell T-shirts for the lifers. I'm the kind of guy that if you

say, "Bruce, I need you," I'm there. I'm not a leader type, but I'm a background person.

I'm very quiet. I do what I need to do and get out of the way. I've never been a troublemaker. If I see a situation that is going to erupt into something no one wants, I'll step in and try to cool it down. That's just the kind of person I am. But I don't like to take any credit for stuff like that; I just think it's the best thing to do. And it helps everybody in the long run.

I came into the system at about twenty-four years old. I had a pretty good family life. I had many friends. I wasn't a bad or dumb guy, but I wasn't using the resources that I had. Once I got over my anger for being stupid and getting myself in this situation, I said, "Bruce, it's time to do something." I started sweeping the corridor and one thing led to another—school and then work. I had these capabilities before I came to prison. I just wasn't wise enough to use them.

I'd like to get back out there with my children before I die and before my mom dies. I realize that the family of the deceased maybe doesn't want me on the street, and they have a right to feel that. I don't have any problems with them feeling that way, or

with doing time for the crime I committed. I own up to that. My only problem is how much time should I do? When is it going to end? And how is the family of the deceased benefiting from my remaining in prison for twenty-five years? I don't see the logic in it.

2017

I've been incarcerated for forty-two years. It's a lot of wasted time. I've become a grandfather and a great-grandfather. It was hard enough watching my children grow up and now I'm watching my grandchildren become young adults. It's a little tough to deal with, but I always reflect back on the person I killed, what their family is going through. Or that his children now have grandchildren and great-grandchildren. At least I get to interact with my grandchildren and my children. I'm thankful for that.

What keeps me going is that I've educated myself. I got my bachelor of arts degree from Villanova. I was in the dental lab for nine years. I got involved in different programs: restorative justice and Alternatives to Violence and groups like that. I read a lot more now since I graduated from college, and I feel as though I can be an asset to young people coming in here.

I have hope. I've always had a great spirit, even before I came to prison. The way I keep it up is that I mind my business, educate myself. I want to be a better person now than when I first arrived. I talk to young people a lot. I try to help them, give some of my education back to them. Things like that keep me going. I'm self-motivated and I take pleasure where I can find it. And I've always been a smiler, ever since I was a kid. It's part of my DNA.

I do have down times. I lost my mom several years back and it's still a soft spot for me. But I have to go on and do this time. I told myself when I was first incarcerated, "Your main focus is to survive." And I do that every day. I take that from my reading about the slave period. The older people said, "Don't go out there starting problems, because the one thing we don't need if we are to survive is to cause problems and have everybody killed or harmed. If we survive, we can reach greater heights." That's my motivation.

I like reading things by and about African Americans. I just finished reading the two Barack Obama books, *Dreams from My Father* and *The Audacity of Hope*.

I've learned that no matter where you are, what you do, who you are, or who you think you are, you always have to give back. You have to reach down, reach back, and help others. You can't do it for something in return. It's little things like writing or reading a letter for somebody, or sharing books with people who might appreciate them.

I give my time to young people because I wouldn't want my children to come into this institution and not have somebody who's older that they could look up to and be friends with. I tell them about my

process and what I've been through. And they sit there, listening. They don't cut me off; they allow me to speak. I always felt I should have been a counselor. I have a lot to say to them about how they should conduct themselves, what they should be getting involved in. I've always believed in the philosophy, "Each one, teach one."

I'm proud and satisfied where I am right here, other than the fact that I don't know if I'll ever get out. I think I've done everything that's humanly possible to show that I deserve a second chance. I hope others will think so, too.

—————————

Bruce died in late January 2021 from COVID-19 while still incarcerated. In December 2020, the Board of Pardons recommended him for commutation. At the time of Bruce's death, the recommendation was waiting for the governor's review and signature.

Yvonne
Cloud

*I took a life, now I try
to save lives*

Early 1990s

A life sentence is like nothing to hold on to. You don't know if you are ever going to get out. You don't know if it's temporary. It's like being in total darkness and you don't know if the light is ever going to shine through. But although I'm in a bad situation, there are people in worse situations than mine. There's always somebody worse off than you. It's not like it's the end of the world. I'd rather have a life sentence and be alive than be on the streets dead. I hold on to hope. You just got to keep yourself positive and hold your head up high. And take it day by day, one step at a time.

It bothers me if I see family too much. It hurts me to see them and remember the past. I see them once in a while, and when I do, I'm happy with that. I think it's the same with them. They bring my son up twice a year and I'm alright with that. I thank God that he's well taken care of. It's one less problem to worry about.

I'm involved with the Pennsylvania Lifers' Organization. I get involved with talent shows and plays. I'm in the choir. I tutor and help other inmates get their GEDs. That makes me feel good because I am a part of something important. Lately, I've been working on a play, so I've been extra busy.

If I had a magic bottle, I would wish to be completely out of this situation and to get back out there and show society that Yvonne Cloud can do it. I am not a failure. I know I can do it. I have changed from within and understand myself better as a person. I have learned to accept myself.

I think male lifers get more exposure because there's more of them. I don't think that a lot of people in society know that there are a lot of women lifers, too. They forget all about us.

2017

I'm more outspoken and mature now. I found my voice and am able to express myself. I'm coping in a better and more positive way that will benefit me, as well as others in the community. Back then, when I was first interviewed, I was somewhat shy, still in denial, and didn't want to talk that much or let anybody know I had a life sentence. I still have the same determination—to do positive things and give back to other people and change their lives for the better. I took a life,

now I try to save lives. Even though I'm here, I can still make a difference and guide other people in the right direction.

Peachie (Sharon Wiggins) was definitely an influence on me. She met me at a time when I was in my twenties, acting like a little kid, running around and doing the wrong things. I had all this potential, and Peachie brought that out of me. It was a sad day when she passed away on Palm Sunday. It was like the whole campus stopped because she inspired so many people. I spent years and years facilitating groups, everything I could grab—inspired by Peachie.

I worked ten years in the drug and alcohol therapeutic community. I recently became a Certified Peer Specialist. I go all over campus helping the young offenders, letting them know that even though they're here, they still can make good choices and not repeat their mistakes. I go door-to-door in the mental health unit, inspiring and motivating people, letting them know there is hope. They can change. People have done it.

I also work in admissions, so I talk to women as they come to the prison, letting them know about all the positive this institution has to offer. People come here and make things so much harder for themselves than it has to be. They come here with two to four years and end up doing the whole four years when they don't have to. It's all in the way we think. If you think positive, nine times out of ten you're going to do positive things. If you think negative, your behavior is going to reflect that.

In 1993, I came close to getting my degree before they snatched away the Pell Grants.[1] I had training for the hospice program. I worked in Project Impact for five years. I received the Lisa Wagner Award in 2004 for all the good things I've done as far as school. I received the Inmate of the Year Award in 2006. I've been doing a lot of positive things for a long time!

Even though I don't know what the future holds, I'm determined to stay on the straight and narrow, and continue to help other people. Pay it forward. Teach others what somebody taught me. That's what I do mostly, even on the weekends. These activities make me feel good about myself, knowing that I'm helping change other people's lives. I am very busy but I make sure I get my rest. It's mandatory, or I wouldn't be able to do any of this!

Most of the older lifers are mentors. You have some lifers, sad to say, who are still bitter, angry about their situation, like there's no hope. Then you have the ones like me who just want to make the best of our situation and help others along the way.

People ask me, "Oh my God, how do you ever do so much time?" I say, "Well, I have no choice in the matter." All I can do is the best I possibly can, take one day at time—sometimes one second at a time—and keep my head up high and be as strong as I can, and give back to other people.

I always remind my family that I'm strong and tell them all the things I do every day. I don't want them worrying about me. Some

people go by what they see on TV. They don't know. They've never been here. So it's our job to let them know that we're okay. I try my best to keep them strong and let them know that I'm taking good care of myself. Thank God my son has never been in trouble.

Doing Life is in the library. It reached all over the campus. A lot of people really appreciate that, and a lot of them didn't know about life sentences. Some inmates walk by us every day and don't have a clue unless they sit down and talk to us. The book brought up a lot of people's awareness about life sentences and how we cope with it from day to day.

It has taken me many years to forgive myself for the wrongs that I've done. I didn't have any right to take the life of another human being—and I have deep remorse for doing so. If I could turn back the hands of time and make a different choice, I would. But I can't. Today I'm still suffering the consequences for my actions on that fateful day thirty-seven and a half years ago.

Joseph Miller

I pray every day for the victim and his family

Early 1990s

Every day is depressing. Every day is the same. You don't go anywhere, you're just here to die. You have to face that and keep faith and hope that someday you will get out and still have some life left to live. Yet as life goes on, you live it and you try to make changes and do things to feel human. We all find our own ways to be productive. You have to keep looking forward and have spiritual strength.

My art keeps me going. I paint everything. Right now I'm working on a project for the chapel. It's "The Last Supper," seven feet by eleven feet. Now we're having exhibits at retirement homes. A guy takes our paintings out and hangs them up and takes them down and returns the ones that are not sold. Two of mine were sold before they were even hung up.

I was watching a TV program, and I saw Bob Ross paint a landscape in half an hour. It moved me. So I tried pastels and then went to painting. Now I'm growing. It helps me as a kind of therapy. I can think, I can figure things out that I couldn't do before.

It's a God-given talent I didn't know I had, and I thank God I found it. I feel like I'm doing something with my life now.

Before, I was a weak person. I was a chronic alcoholic; I drank for twenty-five years. I didn't care about eating; I drank my food. And I was taking prescription drugs with the drinking. That's how I came to be here. Then I stopped and started feeling the real pain of being here.

Alcoholics Anonymous helped me realize that life is pain. When you drink, you're running away from life. Now I have come to realize that I have to stand still and face pain, happiness, everything. It's not that you can run away from it. That's what life is about. Now my art keeps me going.

It's been rough on my family to see me here. It hurts them more than it hurts me. I know what's going on with the family and children, but I try not to interfere in their lives. I'm the one who's being punished, but they're being punished too. It hurts them more than it's supposed to.

If I had one wish, it would be to be happy. To make up for the wrong I've done. That way, I could live with myself better.

2017

I've been in thirty-five years. I'm doing pretty good for seventy-four years old, but I'm starting to feel the effects of aging. Makes me feel like I'm no good anymore.

I was going to sit back and die in prison—let the state stick a bone in me and the dog drag me away. Most of my friends in here have died. But my family wants me to put in for commutation to try to get closer to them. So I'm trying to get out, mostly for them, but it's for myself, too.

I think a lot about what I've done to come here. As I'm getting closer to facing the man upstairs, I pray every day for the victim and his family, and my family. It's a hard thing. I'm not running away from anything. I'm trying to face everything. That's why I haven't put in for commutation before—I didn't want to bring up the hurt that I caused these people. I put a remorse letter in a few weeks ago. To prepare for commutation, I had to go back sixty years, almost to the beginning of my life, to try to remember things. It ain't easy. I'm glad I'm applying, but I don't want to hurt anybody in the process. The victim's family will be at the hearing, and I'll face them and tell them how truly sorry I am. I can feel the hurt in what I did. It's something I'm ashamed of.

I work for Mural Arts Philadelphia, doing murals that are out in Philadelphia. That's our way of giving back, being out there, reaching out. I've got arthritis in my hands and sometimes the brushes fall out. But I still like to create. I believe if you teach a person how to create, they'll think twice about destroying stuff. I stick with painting because that's where I can find myself.

My parents and brother have died. I was allowed to go out and see my parents when they passed. My daughter passed away, but I couldn't go see her because they changed the law. My son is doing pretty good. If I can go home, I'm going to live with him.

Time travels fast when you get older. That's one thing you can't control—time. I wish I could go back in time.

———

Joseph died in prison in 2018.

Aaron
Fox

*You have to have a
dream in life*

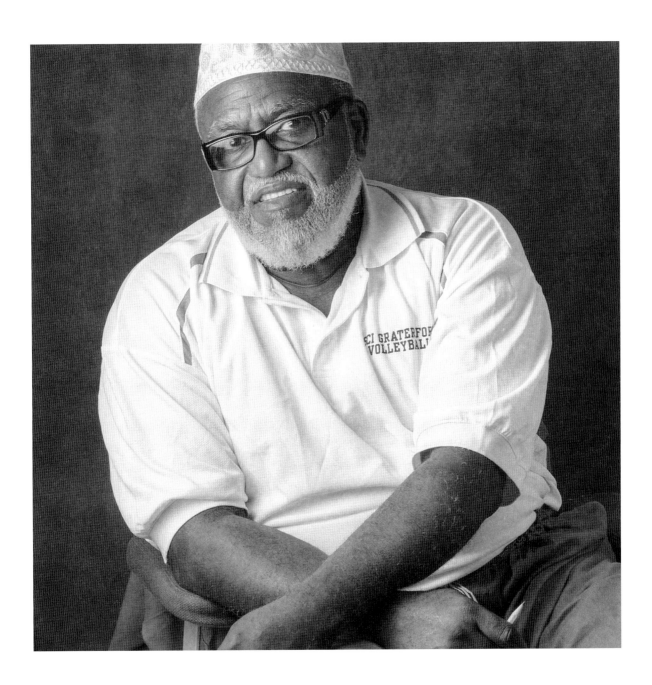

Early 1990s

I would describe a life sentence as doing something you don't want to do, being with people you don't want to be with, being somewhere you don't want to be. Not having your fate within your control.

Life without parole is a death sentence without an execution date. You should be able to live in anticipation of something. The anticipation involved in being without your freedom should be the anticipation of being free.

What keeps me going is faith. I've been a Muslim since 1967. I took it for granted when I was in the street, but I've grown to appreciate my religion since I've been incarcerated. The key is in prayer. I pray five times a day. That discipline keeps me in remembrance of God. It gives me balance. It lets me know that anything is possible. And it lets me know that I'm not really in control, and neither is anyone else who thinks they are. We all have to answer to a higher power. I try to fit myself in with God's plan in the hope that I'll be rewarded by having my prayers for freedom answered.

The biggest change in me since I've been here is tolerance—tolerance and patience. Tolerance for things that I don't appreciate, and patience that if I wait, a better understanding will come to me. This change happened because of the maturation process and constantly making choices and, of course, religion and understanding one's proper role with the Creator. It changes your values and makes you look at things differently. And education too—more information expands your available choices.

I was disappointed when I first came to the penitentiary. I was thirty-four. I was at the threshold of being successful in things that I had been working on over a period of time, economically. My baby was two years old. My life was stabilizing, becoming predictable. And when this came, it shattered everything.

I think the deterrent to crime is family values and culture. If more emphasis could be placed on those areas and creating an environment where a person doesn't have to be confronted with life-and-death choices on such a ready basis, that would be a deterrent.

If I had one wish, it's that I would be forgiven my sins. You never know with your Creator until the day of resurrection, so I try not to repeat anything now that would put me in disfaith.

2017

I'll be seventy-three this year. I was thirty-four when I came in—a baby! I have thirty-eight years in now. I've matured a great deal. My values and beliefs have changed.

I originally come out of the street crime culture. I can tell you exactly when I had a transformation. During the holy month of Ramadan, I was in my cell reading the Koran. Now, understand that I read the Koran, the whole book, at least twice a year. I read it every day during the year, and then during the month of Ramadan I read the whole book. So I was reading, and I came across one line, and it asks a rhetorical question. And it was like I had never seen it before. It answered the question of my whole life. It captured my whole life in just one line. It asked, "Is there any other reward for good other than good?" And I said, "Man I've spent the majority of my adult life trying to take something bad and make something good out of it. I've been bamboozled. Fooled. Tricked!" I've had minor setbacks since then, but that's when I really made up my mind that I was done with crime culture. Now I try to be what I say I am, as a rule, and I think I've been pretty successful.

I have to confess, I've been blessed with a good life, even in prison. This has come primarily through prayer. And I have a vision, I have a future. You have to have a dream in life, and you have to have the ability to realize it by putting a plan together. That's what I do: I work out a plan. My day, my life, is pretty structured. I'm lost without a plan. I get up before dawn, pray, lay out what I'm going to do for the day, pray again at midday, do what I'm going to do, pray again late in the evening.

What I'd say to a newcomer is, "Boy, you in trouble! You got to really buckle down and get a grip on yourself. Discipline yourself, and that means set a plan and watch your company. Don't gamble, don't borrow, go to school, work on your case, and try to find God."

The rap on the young guys is that they don't listen, that they're crazy and you can't talk to them. But I've never met one who wouldn't listen, who I couldn't talk to. I'm not saying they will take my suggestions, but I've never had one who wouldn't listen.

You have to love the youth. This millennial generation, man, they are so enthusiastic, so intelligent and courageous. What they need is proper guidance. There are not enough adult male figures in a lot of their lives. If you listen to some of their stories, man, they're horror stories. And nobody cares.

I have a great family, and that helps keep me going. My wife and I will celebrate our fiftieth anniversary in September. My children are grown and, for some reason, my grandchildren and great-grandchildren still love me.

Diane Weaver

I'm running out of things to do

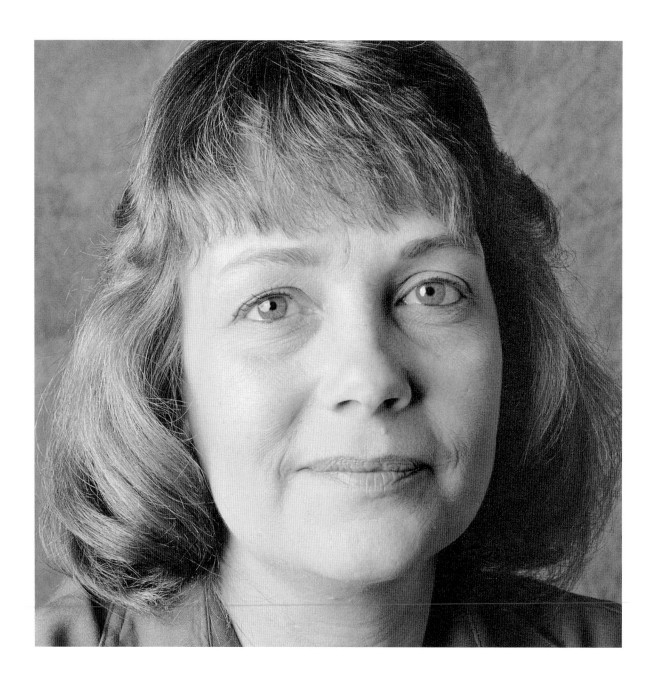

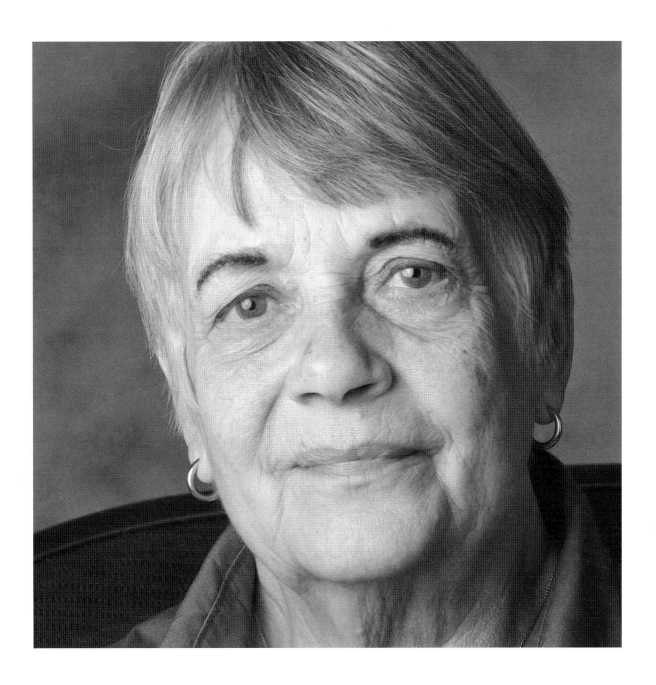

Early 1990s

The longer you are in here, the less ties you have to the outside world. Your family begins to die off. And your friends—how long can someone really stand behind you? They eventually go back to their own lives. That's sad. That really hurts.

It's also been my choice to decrease visits. They're hard for me. When my father visits, it's hard for him to see me in here, and it's hard for me to see him leave. The fact that he's alone out there doesn't help, because I feel my place is out there with him. You feel so helpless because they support you in here, not only morally but financially too. It's like being a child again.

I lived in a prison in my own home with an abusive husband. When I first came to jail, it was a refuge: I didn't have to worry if he was going to kill me. But it didn't take too long for the reality to set in. I've gone through stages. There was a period when it wasn't hard, because the life I had before was rough. When I came to jail, I was safe for the first time. Now it's getting really difficult. I've done everything I can do here. I've taken every opportunity the prison offers.

I'm a touchy person. If someone's hurt, or not feeling well, I want to reach out and hold their hand or give them a hug. You can't do that here because it's looked at as a sexual thing. You get so paranoid. You have to stop and double-guess every little thing you do. And the rules change so often. What might be wrong today might be okay tomorrow.

Some people say it's this way in the free world, too. But you still have some choice on the outside. If you don't like your job, you can leave it. You have the choice to make. You don't have that here.

I come from a strict Catholic background. You didn't get divorced. You live in the fear of God, and the guilt tears you apart. They didn't teach you about a loving God. He's a damning God. Now, since I've joined the Quakers, I've changed.

I don't have any major dreams. I just want to go out and be with my dad because he's getting older, and I don't know how long I'm going to have him. And I have a relationship with a son that I need to get together, to mend some fences. I haven't seen him since he was six. He would be one of my first contacts if I got out.

There are a lot of inmates in here who look up to me. I'm sort of a role model, and

that helps to keep me going. My supervisors put a lot of trust in me. I have a tendency to mother young girls that are coming in. It's probably because I never finished experiencing my own motherly instincts with my son. That's important to me, and I do it a lot.

I don't know where they're getting these women, though. When I first came here, you were scared to death. These women now, they walk down the sidewalk like they're coming to a resort. They're rambunctious, they're loud, they're arrogant. I know I've been locked up a long time, but if this is any indication of what things are like out there, it's scary.

Most of the women who work on the prison farm have a certain cow that they take as a pet, name and spoil it, take it apples. I always have one, and my cow just gave birth. I'm a grandma! I'm just tickled pink. I'm in here telling everybody I just had a bouncing baby bull! I like the farm because you can go out and hug the cows and tell them anything that you want. And you get affection in return. I spend a lot of time with the cows.

2017

It's forty years that I've been in. I'm sixty-seven. This place has changed for the worse over the years. They shut the farm down, so I had to get rid of my bouncing baby bull. There are close to two thousand inmates now, up from around two hun-

dred inmates when I first came here. They put a fence up. The staff are sometimes no better than the inmates. Two officers in my unit yell and call us all kinds of names, like, "You f'n turd." They say the women deserve it because of how the women talk to them. I get that, but you're supposed to be a role model. You never had that back in the day. Everything has gone downhill. It's sad.

I have to be busy, so I got involved in a lot of things. I ended up going back to the Catholic church and get a lot out of being an altar server. I got certified in animal science when I was still working on the farm and also started the dog program. I'm proud of that. I got involved in hospice care. I gave up my single cell to live with and take care of two residents until they died. They would have ended up living down in the infirmary, and that is no life for people. They both died in my arms. It was hard but also a blessing.

I've lost all my family since I've been here. My father was the last one, and I wasn't there to take care of him. That's a heck of a guilt trip! My hospice work may be my way to make up for not being there for them. Back in my parents' day, you took relatives in and took care of them.

The Bible says there's a time to be born and a time to die. When my time's up, it's going to be up and I'm comfortable with that. I pray that it's not too long down the road. I'm not suicidal, but I'm struggling right now with what I'm going to do. I've done just about every job, and I've been

"grouped" to death. I'm running out of things to do and I'm kind of starting over. I'm working in the greenhouse, which I did years ago. That's very therapeutic for me. There is a feral cat program here for the farm cats that got stuck inside when they put the fence up. Staff donated food and took kittens home. The unit they lived under just got torn down and, the other day, a cat was run over by a piece of equipment. That broke my heart. Why should they have to suffer? I got a chipmunk coming to my window every day to be fed. That's just me. I love animals.

The only thing I haven't done is House of Hope, which is for women who were abused. I'll probably do it in the future, but they want you to move into their unit to be part of it. I've done enough moves in my time and I want to settle.

I didn't have a bad life on the street, except the last few years. I'm in here for killing my husband. Back in the '70s, they didn't have domestic violence laws. I'd be beaten to a pulp and would tell police what happened and they'd say, "We didn't see anything. Your husband says you're a klutz and fell down the steps." They knew the truth, but they couldn't do anything.

I used to run some of the drug and alcohol groups. I don't have a drug problem, but I had the same problems that take others to drugs. They would ask, "Why didn't you turn to drugs, with all you were going through?"

I've been up for commutation four or five times. The law keeps changing, and a lot of it is politics. And they always want to do it for the men. Give us women a chance! My cousin would take me in if I ever got out, but what am I going to do? When I came in, I was still dialing the telephone. I had college under my belt, but we didn't have all these computers. Things aren't the same out there anymore—it's not easy. People tell you, "Well, you're better off in here. It's easier in here. You get three hots and a cot. You don't have any responsibility." Yeah, you do!

We used to have a volunteer mentoring program where we took somebody under our wing when they came in. Now there is the Certified Peer Specialist program where you're trained and assigned a unit and people can sign up to see you. It's supposed to be confidential, but there's no confidentiality here. They asked me to join, but I've seen too much. Everything here seems to be done with other reasons. A peer specialist who worked in the kitchen would take food and sell it on the units. There's a lot of things I don't want to get involved in because of all of that. It's going to affect you down the line, in one way or another, because they get pissed that you're not going along with what they're doing, and they are afraid you're going to tell. They make it rough on you. There's a lot of bullying in this place.

I've had something like ten roommates within a year, all young and problem indi-

viduals. Staff says, "Put her in with Weaver. Weaver will straighten her out." It's a compliment, and it worked back in the day, but I can't do it anymore. They need to leave some units for some of us who are decent people, that want quiet, and want it a little more laid-back. They finally put me in a larger room and gave me a roommate who is older and also doing life, so she's not needy. It's helping me out. I need help, but don't take it upon yourself to do things for me. If I want help, I'll ask. But let me do what I can do.

Bruce
Bainbridge

*I struggle with keeping
my humanity*

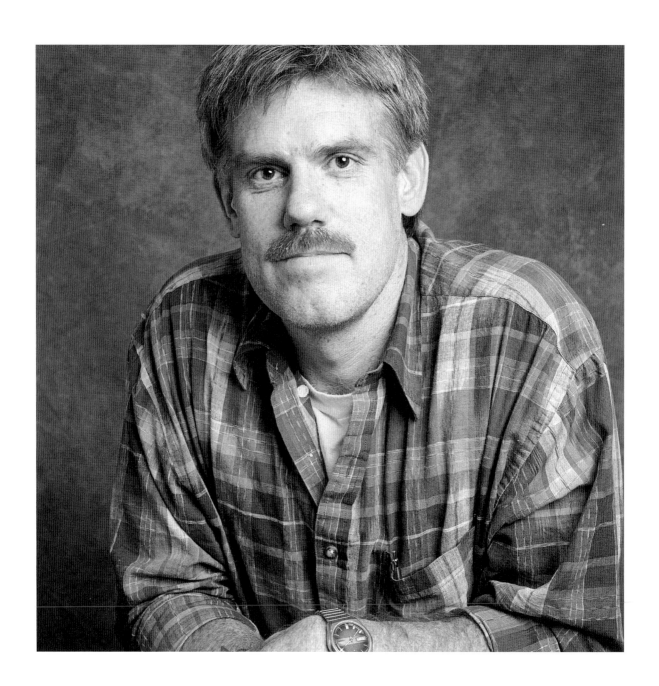

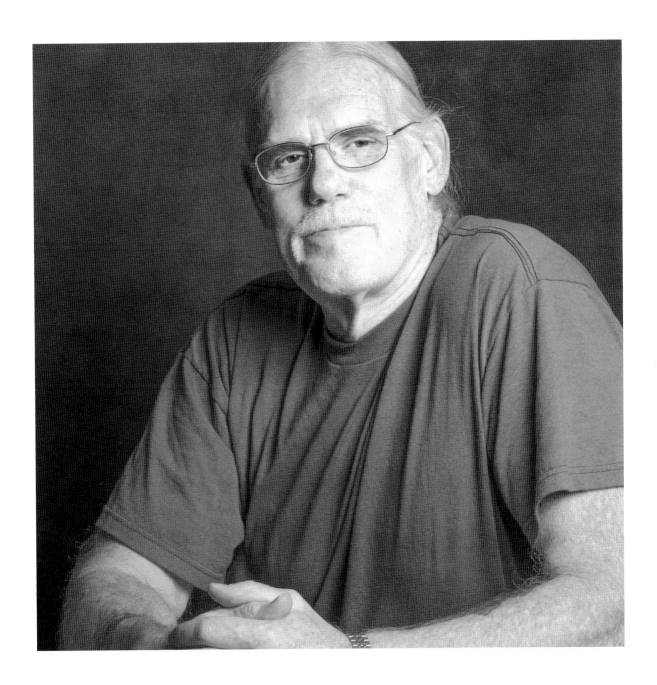

Early 1990s

A life sentence is a tunnel without light at the end. It just goes nowhere. It's an endless black hole that keeps sucking everything in. That's all this place does: sucks you in and keeps you here.

What makes it tolerable is hope. That comes, I guess, from within, from the people around you, from the friends you develop while you're in here. You can't exist without hope.

The Family Resource Center in the visiting room is the whole basis of my existence right now. I consider myself fortunate to be able to interact with kids. I love my own son, but I don't see him, so I feel fortunate to have this. It gives me hope. A lot of bright-eyed kids—they give me energy. A lot of them are starving for affection, for love, and they don't get it from their parents. So we end up giving it, and we don't mind a bit! Working with kids helps you turn around, because they are always looking to you for guidance and direction. You become the adult in the room.

I've come full circle since I've been here. I came in wild with an attitude like, "You can't keep me down. I'm not going to be here long." Now I think more. I'm more conscious of where I'm going. My self-esteem is higher, and I like to reflect.

I don't like my cell. I sleep there; that's it. Other times, I'm at work or somewhere else like the Family Resource Center. It's a dark cell with painted windows and I turn the lights out. I do use a night-light, but I don't like a whole lot of light in there because I don't like the place. It pulls me down, so it's just a place to sleep and get out of.

A lot of funny things happen in here. It's hilarious because you have such a mixture. The guards themselves wander around in a daze, trying not to look scared, handling keys; then they drop them. It's instant panic because they're told that if they lose the keys, that's it. So as soon as you hear a key drop, you see this guy scrambling. This guy is expecting you to grab them. When you see that, you don't bust out laughing. You walk by with a nice chuckle on your face, trying to keep your composure. We already know their keys will only get you so far. The perception of the guards is that we will do anything for freedom.

Once, there were four of us sitting in the visiting yard, making bubbles for the kids in the Family Resource Center. I made the concoction so thick that the bubbles were heavy. They wouldn't bust. They were going from the visiting yard out into the main yard, floating by. "Where is that from?" People talked about that for a while, this unbelievable bubble floating through the yard. Cracked us all up.

2017

When we had to get rid of the civilian clothes due to a policy change in 1995, it was depressing for me because I had to throw away my identity. That's one of the biggest things that gave me character. I didn't want to turn into a prisoner. I still struggle with keeping my humanity. I don't want to get numb to that.

Working with people, adults now, keeps me in touch with my emotions. I don't want to lose them—I want to experience them and process them out. A lot of it is sadness, depression, anxiety, not knowing. It takes an awful lot of deep breathing to collect myself. But I don't ever regret having those emotions. Learning how to regulate my emotions helped me to grow and mature.

Hope is very important. That's the spring I have to humanity. You've got to have some hope: a little vision of hope, and what it could be like, what it looks like. The

vision is a little fuzzy yet, but I recognize it in some of the conversations I have along the way.

My wife Marge helps keep me in check. She doesn't mess around! That's what I respect and love about her. She's a wise person. She's been with me two-thirds of my time here. We've experienced an awful lot. I think there's more depth to us, given our situation, than for most people on the street, because their relationships tend to get normalized. They take people for granted. We don't do that. I'm so fortunate, so grateful that I can rely on her and that she relies on me. We don't really know where we're going, but we know that we're growing old together.

I just finished the hospice class through Temple University. I got a letter from the professor saying, "Thank you, Bruce. You gave a lot of input here. You did a lot of thoughtful writing." I read that four or five times because it was such a powerful reinforcement that, yeah, I did something good. You don't get much positive reinforcement in here. When you get it, it feels good. I have kept track of all that I've done since 1982. It's just makes you feel better that being here is not for nothing. You find ways to take care of yourself, reinforce yourself, do what you need to do to get through this process.

Aging here is learning how to negotiate the system, not on a day-to-day basis, but on a year-to-year basis. We have an aging

population now that needs more attention and consideration for what we are trying to do. We don't want to be harassed all the time, and we're seeing less harassment now. When they see the old guy with the gray hair, the white hair, the long hair, the short hair, the no hair, walking around, they're showing a little more respect. Aging in prison is no joke!

We lifers have been here an awful long time, and we have conversations about what it's been like, what we did, and how this place has changed. We're exhausted, but we have that camaraderie now, which is cool and uncool at the same time. Sometimes we have disagreements with each other, but somehow we find common ground to move things forward, move that needle a little bit. You have to accept it for what it is. You can't change everything. You can't control anything! Most of us are pretty good friends, and some of us are just casual friends, but we all have that familiarity. We've had the same frustrations, we've seen family members and friends come in here, and a lot of friends have died. Those are our somber moments.

We certainly enjoy our single cell status, because we came in by ourselves and were put in a single cell, and so we expect to die in a single cell. The upcoming move to Phoenix, the new prison, is a huge anxiety. When you've been by yourself for an awful long time and then you're told you're going to have a cellmate, that's huge. That really shakes a lot of people. With the move, we're going to lose our property, because you can only take so much with you. You're about to lose your privacy, whatever privacy you have. There's not much that we're allowed to have, but what I have I want to keep. I hold that to be my treasure.

There's advocacy that needs to take place here at Graterford almost on a daily basis. It's exhausting. Years ago, I tried to use restorative justice to transform this place, make it more user-friendly, make it more tolerant. It worked for quite a few years. And then we had a change of administration, and all of a sudden you get more no's on your efforts to maintain basic principles of restorative justice.

Many of us have grown up since we've been here. Our thought processes have certainly changed, so we want to feel and live this humanity, and live a normal life. I don't know how we can sugarcoat that it's a totalitarian system here. It's like, "Feed the dogs two times a day, let them go out to the bathroom, let them run around a little bit, then put them back in."

I've been here thirty-eight years. I was twenty-four when I came in. I'm sixty-three now. I try to take care of what I can healthwise. I'm vegetarian. I exercise regularly. But my parts are wearing out. I have goggles now! I'm not hearing as well as I used to. I have a heart issue. The arthritis acts up a little more. I do a lot of reading and writing. I don't want to fall apart. And I got family

members that I want to hopefully get to. I want to take care of myself as best I can for the time I have left.

Hopefully, I'll be released. That's the hope that I have, that Marge and I talk about, that I talk about with others. Thinking about the things I'd like to do, things I haven't done in an awful long time—that keeps hope alive. A positive outlook, staying active, staying as positive as you can—it's a survival thing. I'm always asking myself, "What is my greater strength?"

Hugh Williams

*Everything we do
has a purpose*

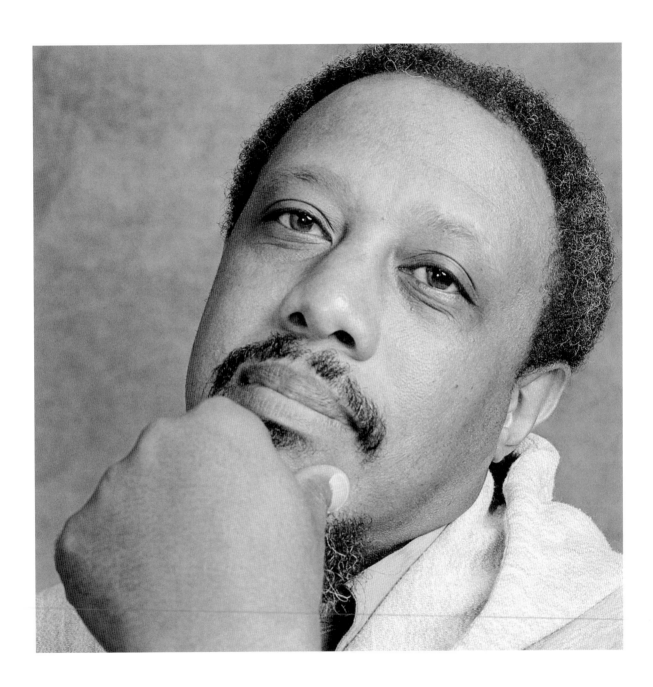

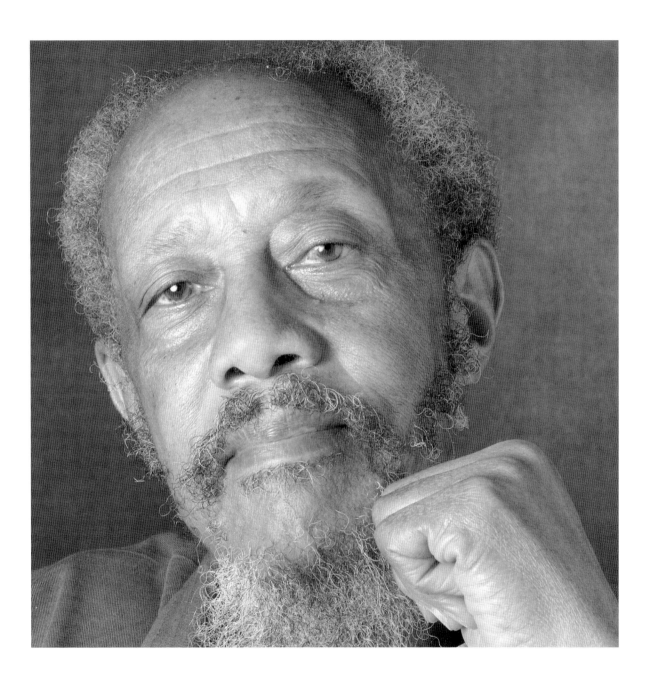

Early 1990s

When my kids got to be about thirteen years old, they began to ask me some serious questions about life. I think the separation strengthened our bond because they felt freer to be open enough to discuss some things that, if I had been on the scene, they probably would have taken me for granted or not have felt as though I would be the one to ask. I think they saw me not so much as a father figure, but like an uncle.

The worst thing about a life sentence is being stripped of any hope. We all have our own hopes within ourselves, but I'm saying what society will grant. If a person is laid off work, he can get unemployment and food stamps. There are mechanisms to keep people from falling through the cracks, a backup system in society. But in this system, there is no backup. You are just thrown in the penitentiary and told to do it until the Creator calls you back. You have to accept the fact that there is no hope, except maybe a new law or a new case that may change the parameters of your case. This impacts how you relate to your people, because it is very difficult to always be upbeat. Not that you are bereft of all hope, drowning in your tears. It's just that you can't say, "I'll see you next year at the family gathering." Instead, it's always, "I'm sorry I can't be there with you. Maybe next year." There's always a lot of maybes. There's never anything stronger than that.

When a person lies down to sleep, it means more to a lifer to have accomplished something during that day. I tell you, everything that we do generally has a purpose. We have to fill our days with responsibility. You can't just lay to waste. You'll find most lifers are the heads of most groups in here, or at least a voice to be reckoned with.

In here you don't have the luxury of taking a vacation from work. If you take a vacation or give up, you set yourself up for a downfall. It's like being terminally ill. Some people just decide they're going to give up and wither away and others say, "I'm going to extract every bit of life that I can and try to go out struggling."

If I could turn back the clock, I'd go a lot further back than the incident that brought me here, because there are building blocks that led up to me coming to the penitentiary. I would have to go back to the beginning of my thought processes, in my early twenties. I would ask for time to stop

there so I could regroup and reappraise my thought patterns.

In some ways, though, my life is pretty much the same as it was on the street. I work every day. I read. I am active in the community. I don't really think I represent the stereotypical image of someone in a penitentiary. On the streets, I was buying a home. I had a car and money in the bank. I had family. I voted. I graduated high school. I served honorably in the military. Except for the event that brought me to prison, my life would probably be equal to millions of other people's lives. I'm not the guy that had to come in and learn how to read and write and never had any responsibility.

I've come to grips with the situation that brought me here and just continue the same lifestyle that I had been living and figure out how to make it from day to day. It's ironic. Old debts were forgiven in World War II. You had a devastating war that the whole world was involved in. But after a while they decided, "You guys can't pay your bills so we're going to wipe the slate clean." These were enemies, but somehow they found it possible to forgive. Yet the people in this society don't want to extend that same courtesy to its own who have made a bad decision. They seem hellbent on exacting every ounce of blood and every pound of flesh.

2017

I've been here since '73. Forty-seven years now. I was twenty-nine when I was arrested. I haven't really changed that much, except I'm a senior citizen, so I get a few perks. I don't have to show my ID card as I go around the prison.

With the amount of time that I have in, I've been a mentor. I've raised sons, some little brothers, and a grandson here and there. I try to be as helpful as I can and look out for the young guys. It's a chore because they got the bodies of men but the mentality of children. I don't know where they come from, but that's how it is.

My granddaughters asked me to write a narrative of my life. I started with my birth and stopped after I graduated from high school. Then I said, "No, my life is more than that," so I wrote another narrative all the way through the military. My oldest girl then asked me to write up until I met her mom. So I did. I wrote almost three hundred pages. I asked them to pass it down from generation to generation. I was happy my granddaughters asked me to do this because there are things families don't talk about. It gave me the opportunity to flesh out my life. These are things that keep you going.

I still play racquetball. I still "got game" and am pretty hard to beat. I'm the oldest guy out there and everyone thinks I'm a pushover, but I say, "No, I'm an old man who knows a little something." I work in the library. I have access to everything and have

always liked to read, so I'm in a nice spot. I like to read historical novels and science fiction like Isaac Asimov and George Orwell.

You have to keep moving forward or else you go backwards. You can't relive old times. Some lifers get stuck; they didn't have a plan of what to do with their time. I can't overemphasize, particularly at my age, that when you go to bed, you have to be satisfied you've done something. The day is shot if you didn't. I take inventory: "Did I do this right?" Sometimes I forgot something but at least I remember it then.

The secretaries, wardens, whatever name administrators call themselves now, say that if not for the lifers, the jail wouldn't run. Everyone looks to the lifers to solve their problems. It's ironic, because you would think that we would be castaways. Instead, the worst of the worst of society are the best. Let's face it, we're all getting older, and even though the younger generation is a little wild, they still give the elders their due. We know a whole lot more about the system, and the system looks to us to lead.

Harry
Twiggs

*We can draw from the first life
and see our mistakes*

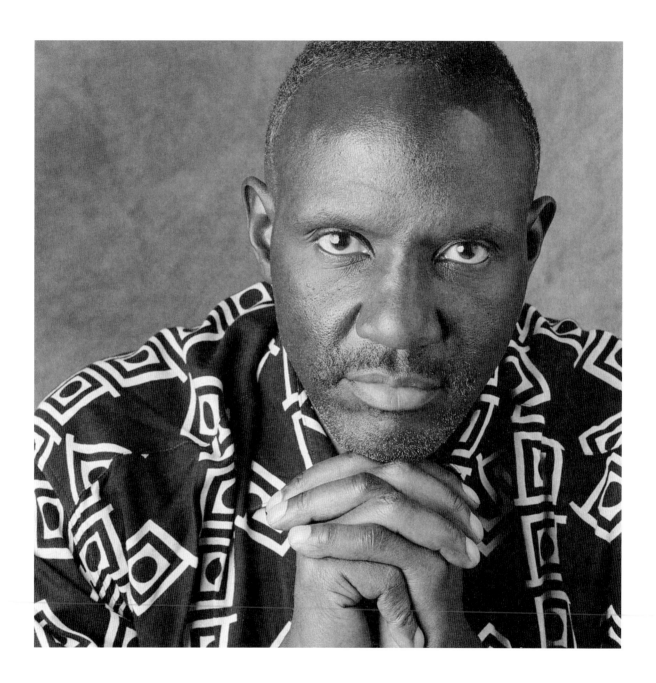

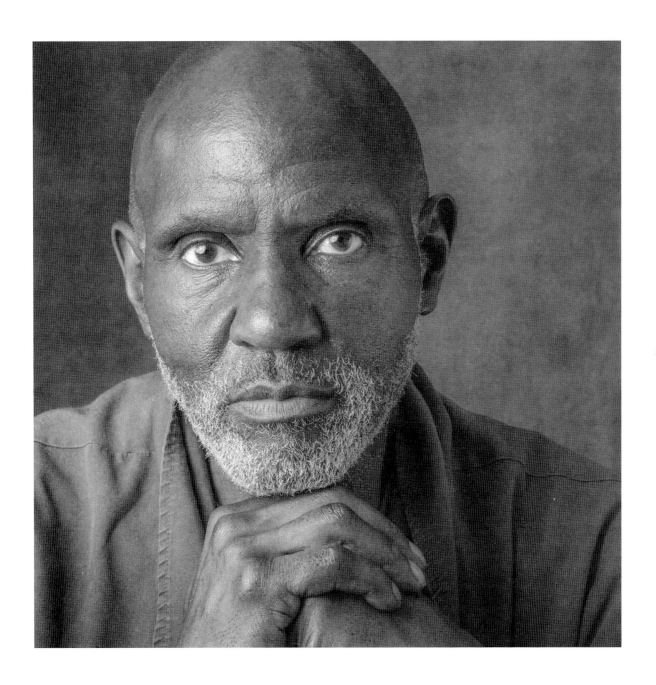

Early 1990s

From what I hear from people who come in, they talk about me on the street as if I'm dead. A life sentence, in essence, is death. It's one step away from it.

When I came in, I was a cocky individual. Didn't care anything about anybody but myself: a self-centered person, full of hate, resentments, bitterness, anger. I thought everybody owed me something, and I was planning on taking it from everybody. I didn't want to work for it; I'd rather take it from them. Now I'm forty-five years old, and I've been here twenty-three years. I'm a man who has come to grips with himself and the world around him. I understand that I am only here for a while, and that I should try to make the world a better place than it was when I came here. I feel remorse for the things I've done in my life, and I want to try to make it up to the people that I've done it to and to society as a whole.

I'm still a person that is driven, assertive. I still believe in causes, but now my causes are positive as opposed to being negative. Before, at the age of twenty-two, I had a cause. I wanted to get high. I was a drug addict. So my cause was to get drugs any way that I could—to rob, steal, whatever I had to do to get high. At forty-five, I get high off bringing kids into this institution and telling them not to do the things that I did when I was their age. I get high off accomplishments. I still have that same drive and that same determination, only it is for something positive.

What made me change was a combination of pain, suffering, and being in prison so long. Then I became a Christian, but that was only after three or four years. It was mostly the pain and the looking to see that I'm never getting out of here. I mean, you got positive thoughts for maybe five days out of the week, right? And then two of those days you would be saying, "I might die in here." That stark reality hits you sometimes.

I look at it like this: the pains that it took for my mother to bring me into this world—all I brought her was pain, all my life. I started reflecting on the pain I caused her, on my never being able to do anything for her but cause tears. Having her see her son sentenced to life in prison, her being a Christian woman, knowing that her son had killed somebody . . . all these things, it was totally against everything that she had ever planned for me in my life. I want to

see her justified for the pains that she went through to bring me on this Earth by doing something for somebody else.

Ask me how I got like that, man, I can't even explain it. Really, I think it comes from poverty. We had seven siblings in my family. My father had a job, but it wasn't paying enough to take care of all those children, so we lived in the ghetto in extreme poverty. When you grow up like this, the struggle takes all. You fight to eat; you fight to survive. I'm talking abject poverty. It takes from you the spirit. You have to crawl and fight, and it kills that spirit in you that makes you care about other people.

Self-respect is part of it. Because you don't have anything, you try to distinguish yourself from other people. I started robbing people by sticking them up with a gun. I might have some new clothes on then, and I was automatically put on a pedestal. I was given status because I had robbed somebody, or because of what I bought, not because of who I was on the inside.

I had low self-esteem because of my complexion being dark. I thought I was ugly, and this made me mad and angry. I had pain in me, and when a person feels pain inside, they want to make somebody else hurt. You don't give a damn: I think I'm worthless and no good. Because I feel like that, I'm walking around with an arrogant attitude. I don't have nothing, so I don't like you or America because you got something. Therefore, I am going to hurt you. That's what happens, man.

I see all my youth wasted. Twenty-three years wasted in here. Years I can never get back. Productive years. I feel sorry and I feel remorse for what happened. If I, a forty-five-year-old man, could go talk to my twenty-three-year-old self, man, I would tell him to get an education. I would tell him to stop and get that anger and hate out of him. But he's gone. I can't be lamenting about the past. All I can do now is try to talk to other twenty-three-year-old guys that I see headed in that direction—try to talk to them because I can't talk to myself anymore.

A life has been taken, a Black man the same age as me. He pulled the gun on me, we struggled for the gun, and I got the gun and shot him in his head. He's dead, and now I am being killed slowly right in this prison here, and it doesn't have to be that way. I can make a contribution out there. I took a life, but I can save lives now if I'm given a chance. I can go outside, and I can talk to kids in my community, because I know what's got them. I am not saying that I can save them all, but there are some who are at risk that I can get down in the mud with and save.

I don't want no money, no big car, none of that, because I know that none of that means nothing. When I am dead and they land me in a casket, I want people to say, "Yeah, his life started out bad, but it ended good. He was a bad person in his youth, right, but look at him, what he did before he died. He helped people, he saved those

kids, and he started programs out here for children, and he went back into prisons and he taught the gospel." That's what I want my legacy to be.

2017

I've been inside forty-five and a half years and I'm sixty-seven now. I'm still doing the same work. The culture of crime is a problem in our neighborhoods and community. I see it in the guys coming every day inside the prison. There are men in these prisons who have come of age; we've made our mistakes, we've learned from them. What we're doing now is trying to change the culture of crime on the streets and the culture inside the penitentiary.

The new guys are disrespectful. They have no morals, are unprincipled, and they have no rules that they live by. They hate themselves; they hate everybody. They're violent; they hate their mothers. It's this environment of coldness and callousness that exists. This is the result of the street crime, the culture that I was architect of and many of us were. These are the grandchildren of the men who were killed in the '60s and '70s. This is why I have to continue to do what I'm doing in order to give back.

It helps keep me going. Plus, it's good for me, because I see myself in them all the time. It keeps me grounded and I learn a lot about them, about me, through them. I'm able to identify some of my character defects that I may still have, that I see in them. It's good work. It's reciprocal—both ways.

I believe that we all are blessed with two lives. The first life we live, we make all the mistakes. We commit crimes, we hurt people. Once we wake up and move into our second life, we can draw from the first life and see our mistakes, learn from our mistakes. Not only can you help yourself, you are able to help other people. My job is to plant a seed for change.

I'm grateful every morning that I get up and am able to live another day. It was really helpful for me when I got in touch with the fact that my decision-making was broken. When I make my decisions, it's like, "Is what I'm about to do going to help somebody? Help me?" If that's the case, then I do it. If what I'm about to do is going to hurt myself and hurt somebody, then I don't do it. When I make decisions, I talk with people. If I got an idea, it could be coming from the old me, so I ask someone if they think it's a good idea. I know I can't do it on my own.

I got into recovery and became a Christian. Therein lies when my second life began, the rebirth, being born again. I fell in love with recovery more than I did with the church. Those guys in AA were my type of people. They thought just like I thought, and they were getting better. I embraced that wholeheartedly. I rose up in there. I refer to myself as an addict and a recovered criminal. I do that to remind myself that criminal addiction, like alcoholism, is a disease.

The fact of the matter is that I'm allergic to drugs and alcohol, and I'm also allergic to crime. Whenever I do any of those things, I break out in spots. Spots like Camp Hill prison, spots like Graterford prison, spots like Huntington prison. I remind myself that I have this incurable disease, and that I have to work on it every single day. Sometimes every minute.

One of the counselors told me, "Your problem is not drugs and alcohol or crime. Your problem is you! You have a Harry Twiggs problem. You just use drugs and alcohol as a supplement to try to make yourself feel whole. You got to work on you and find out who you are. Find out what your strengths are, your assets, your ability." That's what I've been doing in this recovery process. I've been finding out who I am. Learning that God doesn't make junk. Forgiving myself, removing the guilt and the shame that I had about who I was. Seeing that I can use the wreckage of my past to help others. Today, I know that I am who I am, and I know that I have worth.

I didn't know how to express my feelings, and I was scared to express them. I couldn't come and tell you, "I'm scared," or "I'm confused." All I was allowed to express were feelings of anger, hate, pain. We looked at any of those other feelings as being sissified, like "You soft." Therein lies the fact that we were just walking around full of anger, we were hurting, and fearful. I was one of the most fearful individuals in the world. I feared what people thought about me.

Now, I know I can go on the street and help people because the antisocial human being that I was has been transformed. Transformation is a lifelong process, and I know I got work to do. I'm still an addict, alcoholic, and recovering criminal. I don't try to act like I'm not. I still know how to do the things that I used to do, but I choose not to do those things today. I'm able to show people how to find their way. I'm using it in here, but I'd like to be able to use it on the outside.

I'm up for commutation now, my seventh application. I was put in prison because I was a danger to society. I realize that. They did the right thing. But now, having lived in prison for the past thirty years as a responsible, model prisoner? I've worked in the recovery program. I've started programs at different prisons I've been at. A Youth Awareness Program. A version of the Day of Responsibility. An Old Head/Young Buck session where we bring together bucks and let them talk. I got the Certified Peer Specialist training. I've made a responsible life in here. I'm no longer a threat. Why do I have to continue to be held in prison, when I can go out there and replicate exactly what I'm doing here? How much is enough time? Especially after the prison has done what it's supposed to do as far as transforming and changing individuals.

I don't really think a person should get out unless he is working some kind of recovery program or change process. Left to my

own devices, I can always do more things to hurt myself. I need help. I can't do it on my own. Willpower is not enough. I need to be held accountable; I need people that I can go and talk to.

I don't get discouraged because God keeps me up and I'm constantly busy. I'm never in my cell. I'm the hardest-working man in the prison. I work seven days a week. I'll take a day off when I die. I'm trying to make up for all the years and the pain and the suffering that I caused people. I took a young man's life. I've introduced drugs to people and got them killed. Hurt my Mom, hurt my family, the people that I said I love. When I leave and go out on the street, I'm not going out to try to get power, pleasure, or prestige. I want to come out and do things, help. That's why I can never go back, because there's too many amends that I have to make.

When I leave out of here, I'm going to take one day at a time. I'm not concerned about what's happening in the past or what's going on in the future. I just want to live that day and do what I can do to help someone in that day. If I'm out there helping, that keeps me clean.

Gaye Morley

Seeking that inner peace

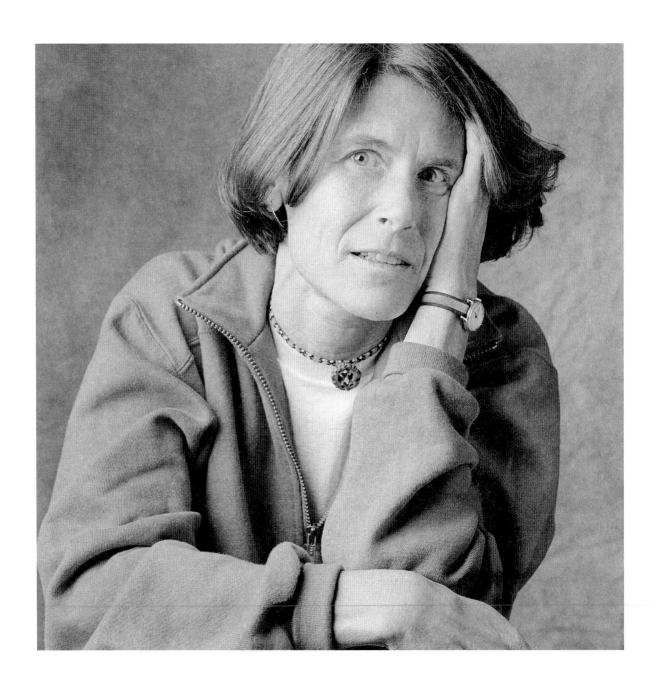

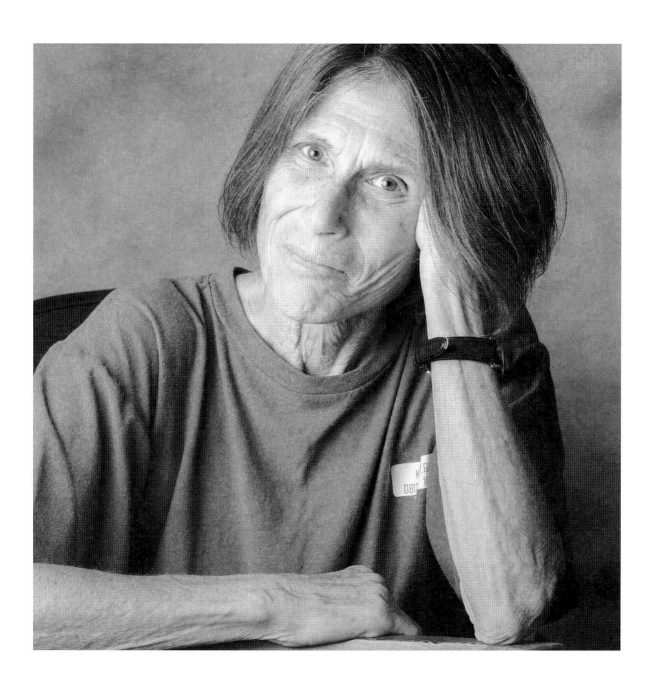

Early 1990s

I've been in just two years. The first year was a real struggle trying to adjust. I was overwhelmed. Then I went through a period of extreme withdrawal. Then some of the bitterness and anger started coming out. I said, "I don't like this; I've got to pull myself up and start doing something." And that's where I am now. I still want to be a whole person. I want to be a good person and I've got to go for it.

At this point, I'm just trying to deal with my crime. The hard part is not being able to talk to anybody about it. I want to. I'm lucky right now that they hired another psychologist and I started seeing her, so hopefully I'll be able to talk through some things with her.

One of the things I have a lot of difficulty with is all the anger that's around me. And I'm finding it in myself now, too. That's scary. I never felt a lot of anger in my life. At times I would feel a lot of hurt. I can see now where the hurt can build up into anger.

Ten years from now I hope I'm not here. But I know I will be. I hope ten years from now I've gotten myself together enough that I'm contributing to others in this institution. I don't want to become a bitter, angry person. That's the last thing I want to come of this.

A life sentence is a vacuum. Everything is being sucked out of me, leaving me nothing. I know I have to fight that. I have to create a whole world within myself and hopefully be able to spread that to those around me.

2017

It's getting harder. When I came in here, it was a lot easier. The population has changed. It's crowded. It just seems more like prison. There's a lot more anger around the campus. I'm getting older. There's really no place to go.

I love being a Certified Peer Specialist; it keeps me going. I work by myself and I like one-on-one contact with the ladies. I can relate to them, and I like being able to encourage them and try to keep them on a good path before they get detoured. Sometimes psychology staff in the special needs unit say, "Gaye, can you check on this one?" I give those ladies support. One lady said, "I am so scared to go over there; everybody

is crazy." I said, "No, we all have issues. It's a nice spot and there's a lot of activities over there." She went, and as soon as I saw her out on campus after that she said, "It's nice!" I said back, "I told you it's a good spot!" I'm able to do something where I'm giving back. I did hospice for years, too.

I do my yoga and that's my peaceful spot, my routine. I told my new roommate that it's my thing that I have to do in the morning. She asked, "Does that really help?" and I said, "Yeah. Maybe I'll get you down on the floor to do some yoga with me!" The yoga, meditation, and any spiritual things that I read all help me. I don't follow any one religion but relate more to Eastern and Native American thought. I've learned that you have to have peace within yourself. Sometimes it's hard to do, but you have to constantly keep at it and not let the outside knock you over.

Little things still make me happy. I look out the window and say, "Oh, the sun is coming up!" I don't know if it's spiritual or whatever. One time I thought I was going to get moved from my cell again. I got up, did my yoga, did my breathing, did my meditation, and I just sat there. I said, "Whatever happens, it will be okay." I'm seeking that inner peace. I sometimes separate myself because I don't like to hear or see a lot of what's going on. I can contribute something to help someone else feel calm. Some of the ladies say to me, "You're always so calm and peaceful. I feel relaxed after I talk to you," and I say, "That's good!"

I think everybody should have a chance for parole. I don't think everybody should be released though; it has to be on an individual basis. A life sentence is no different than being on the outside. You can only do it one day at a time, and everything that goes on out there, also goes on in here. The rules keep you on your toes. You can't get too settled, because you never know when things are going to change. It's just more condensed in here because of the dynamics and overpopulation. I don't count time. I never did that, because I think that from the very beginning, I never looked at myself as leaving.

I'm not requesting commutation. I was working with a therapist, and around year fifteen he brought it up to me. He said, "Look Gaye, you've been here x amount of time. How about considering commutation?" We went back and forth on it, and then he whacked me with, "If you were talking to somebody, and they shared what you shared with me, what would you say to that person? Would you suggest they go for commutation?" I said, "Yeah, I would tell them to," and he goes, "Well?" So I thought about it and had a friend of mine send me the paperwork. I started looking at the questions, and all of a sudden it hit me: they are going to notify the victim's family, and they will have to go through this all over again. I couldn't do it. I've been able to work through the crime myself, but to put them through it? No. I accept being here. I'm okay with that.

You can't undo what you did. All you can do is try and make yourself a better person and contribute to something worthwhile. It doesn't have to be monumental. The big thing is to try and keep that compassion and reach out to anybody you can. Give a smile. You don't know what it will do for somebody. I used to pass this woman, and one time she stopped me and said, "Every time I passed you, you said hello or smiled or said some positive thing to me." I said, "That's kind of who I am."

I am grateful that I have not allowed the years here—all that I have seen, heard, and experienced at various times—to harden me. It has made me an even more sensitive and peace-seeking soul. In these later years of my life, at sixty-eight, there is an inner peacefulness I am more able to tap into as I go through each day.

If I was ever to leave, I would just want to be somewhere really quiet. Send me up in a mountain or somewhere out in the ocean, or to a nice retreat, just for centering and things.

Kevin
Mines

*It's part of my spirit
to help people*

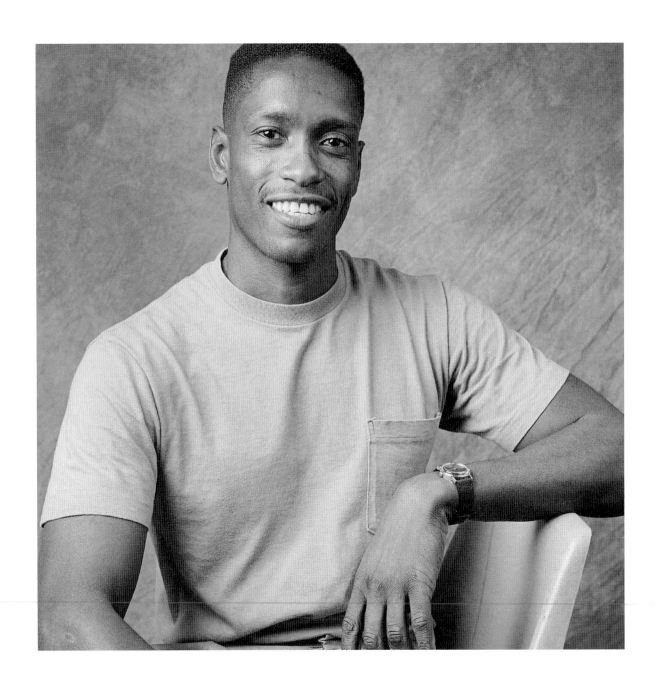

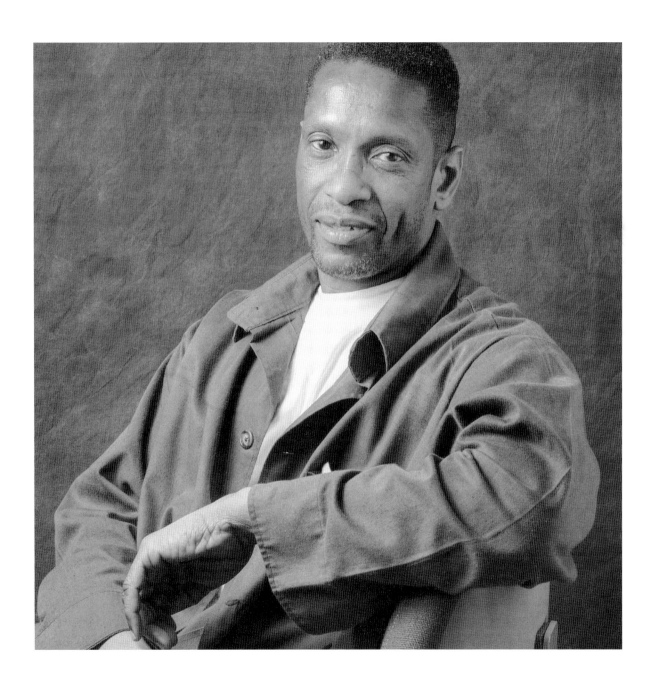

Early 1990s

Waking up not knowing what the next day will be like, whether you can be in a riot or get hurt, is scary. But the real dread is of losing your family, your loved ones. They get away from you. You don't really know them anymore.

I have changed dramatically since I came here. I'm more committed to developing myself. I got my GED and am taking some college courses. I'm active as a member in the Lifers' Organization and I am a pen pal in the Youth at Risk program. Through letters and videos, I share some of my experience here and on the street growing up, and hope to direct the youth in a positive way, encourage them to stay in school and stay out of trouble. And that this isn't an experience they would like to share. It's great to know that you can help someone. I also work with the lifers on a bill proposing parole eligibility for lifers in Pennsylvania. Right now it's stagnated, so there isn't much we can do on that, but I think we did a good job in trying to convince the legislators that it's a worthy consideration. I also have a program of my own, called the Community Involvement Program, where people from different sections of the city come inside, and we discuss the needs in the community and how we can improve the conditions. I'm currently assistant secretary for the NAACP, which is trying to influence the men here to adopt a more positive and serious attitude. I'm a member of the Jaycees, which is helping the younger men to understand the importance of family values. I'm trying to make up for things I did while in society.

People think there is no hope so they adopt the attitude of, "Why should I try? I'm never getting out of here." I try to keep a more positive attitude and always think that there's hope. I work constantly to improve myself and to have an effective plan so, in the event I do get out, I'll have some goals for where I want to go with my life. I recommend that a person strive for all the goals that he would strive for while incarcerated in order to have a successful life on the other side of the wall. Eventually, a guy may get out of jail, and he would be able to utilize those.

A lot of my friends growing up were Muslim. I liked their calm state, their patience,

and the way they presented themselves. So I did a little studying on it and I saw that Allah Islam is a very simple religion to practice; it basically requires that the individual does what's right. It has been helping me through my incarceration, dealing with my own problems personally, staying in a calm state of mind.

In prison, you have to always be cautious and consider violence as a possibility. You're dealing with some people who are very kind and patient, and some who are very mean and can get ugly at times. You hope for the best, but you expect the worst.

People here have some of the craziest questions and say some of the craziest things. You can't understand where they get these ideas from. Every day, guys yell things out that you never imagined anyone would say out of their mouths. They're funny because you have to have some type of humor in your life.

If I had one wish, I would ask to get out of jail and have the opportunity to reestablish my family life and myself as a productive citizen in society. Do the things the way that I should have done the first time I was out, like being more active in the community and with children so I could influence those who may be heading in this direction. Incarceration is an experience that sticks with you, but you can share it with people—not to intimidate them, but to try to convince them that this isn't a worthy lifestyle.

2017

I'm fifty-six now and have been inside for thirty-four years. I had just turned twenty-two when I came. I've matured a lot. I'm not too playful, don't have a whole lot of idle time on my hands now. I'm more actively involved in organizations, work, and school programs.

As president of the Lifers' Organization, I am consistent. I'm easy to confront and talk to, and I'm a people person. I don't have a selfish drive. It's about the larger picture. There are a lot of men in here who helped me discover who I am and who I was when I came here—not too mature, just wanting to have fun. After a while you realize it's serious, and you have to figure out what you can do to help yourself get out and back to your family and community. The older guys gave me good advice and encouraged me to do what I was supposed to and stay out of trouble and harm's way. Now I watch a lot of those guys grow old, get sick, and pass away. Some gave up hope. A lot of them are still fighting, so I try to help. When one of them gets relief, it ensures you that your struggle is not in vain. It's part of my spirit to help people.

I'm optimistic most of the time. I get discouraged, but you can only be discouraged for so long before you finally realize that you just have to adjust to the system. That's what I do—try to dance around obstacles or work within them.

We just received recognition from the Pennsylvania General Assembly and the Philadelphia City Council for the lifers' work helping to save lives here and on the street. We feel great about our work finally being acknowledged. We had the Public Safety Initiative where 150 dignitaries, criminologists, and judges came in and embraced our project called Ending the Culture of Street Crime. That took off and started a lot of great movements in here.

I'm getting commutation paperwork together now. I really didn't have a lot of hope for commutation in the past, particularly because of one governor. Now we have changed to a governor who pretty much said that if you make it to his desk, he'll sign it. He's been consistent with his pledge and has been signing them. The timing is right to apply. Juvenile lifers are leaving. More people are talking about second chances for lifers. Pennsylvania House Bill 135, which calls for parole eligibility for lifers after fifteen years of incarceration on a case-by-case basis, is pending now, with support from thirteen legislators. The Sentencing Project is calling for everybody to get reviewed after twenty years. It's been uplifting and a little rejuvenating to the spirit after all these years. We feel good about all the work, and after a while it pays off.

I converted to Islam when I got to Graterford, but I grew up in a Christian environment. My mother took me to church all the time. I used to hide in the back of the car because I didn't want my little thug friends to see me coming home from church. I always begged my parents to let me out of the car before we got to the street that I lived on. They'd accommodate me a little bit but, if I acted up in church, I got driven all the way home! My friends would see me coming out and it messed up my image! When I converted to Islam, it helped me to settle down and become more sincere about life.

I was not a problem kid. I just had an attachment to the street culture and hanging out with the guys who'd wind up in trouble all the time. As you mature, you start learning and seeing things differently, and then you finally get it. Unfortunately, it's late in the game. But you can take what you know now and pass it on to other generations and other kids. Hopefully they'll get it before it's too late for them.

A life sentence is death by incarceration, death by torture. It's a long, slow, drawn-out process. I've seen people who think that one day they're going home go crazy when they realized they have a life sentence. People give up.

The lowest point was when my parents died. A brother and sister have also died. That's always hard, particularly knowing there's nothing you can do about it. Life and death are inevitable. I think I prepared myself pretty well to adapt, and change, and cope with it. Fortunately, there were ten of us and so we got a lot of grandkids. I have

plenty of outside family who I stay in contact with. I called a niece I don't really know too well, and she wouldn't come to the phone. When she finally did, I said, "What's up? Why haven't you come to the phone?" She said, "I don't know you like that." It crushed my heart, but she was right. I talked to her mother later about it and she said, "Yeah, I told her not to talk to strangers, but I didn't mean you." It was really funny.

James Taylor

*I was in a prison of
my own mind*

Early 1990s

This is my twenty-first year. I am constantly thinking in terms of how much life I have left. A life sentence is an endurance test. You're enduring in a vacuum.

What makes it livable is meaningful activity. I've been very active in pursuing my own growth and development. Education was important for me, and I was fortunate to get involved in a trade that I enjoy. I'm a dental technician now. But the most important aspect of my education was getting a business degree.

Another important thing was my connection to people who befriended me from the outside. Friendships, my family—those contacts were very meaningful for me.

But the main thing that has made it bearable is my religious life. I'm a Muslim, and I've been quite active in the religion since I've been in prison. When I came in, I didn't have direction for my life. I got in touch with the Creator. I asked for some guidance. I asked for some forgiveness. I asked that I be allowed to live a meaningful life. It was a blessing that I could pursue the things that I have.

When I was younger, with a different mind, I attached my accomplishments to material things like property and clothing. Now that stuff doesn't matter that much anymore. I have taken a lot of focus off myself and placed it on other causes and people. I realize that my life is just one life; I live in a world and I want to make a difference.

If a genie gave me one wish, I would ask that genie to deliver a prayer to God to bless the lawmakers to grant the parole bill. That bill simply states that persons who have demonstrated sincere repentance and who have worked toward bettering themselves could be released and be successful citizens. This bill would put a mechanism in place so that men and women could be judged on a case-by-case basis. A lot of lifers are ready to give something back to society. This bill would do much to encourage us to reach to the future for some hope.

I was taught that in this country of mine, a person is redeemable. That is taught in this country and in religion. You deserve another chance; you get good for good. I have tried to pursue the good. My greatest fear is that I will have to go down knowing

that I had been told a lie, that I had been expecting payment for work done. And there was no payment.

I find myself wanting to tap all the potential that I have to do something with my life. Getting in touch with my spiritual side and constantly pursuing that through practice has really helped me.

2017

I was twenty-nine when I came in and I'm seventy-five now; I've been in forty-six years. I've gotten wiser. I had an idea a long time ago that my crime is not who I am. I had to show a difference, for me and the Creator. I was determined to make a difference where I am, especially with the program I created. Five years ago, we changed its name from People Against Recidivism to People Advancing Reintegration. It's a parole preparation course inside, and we also have a business outside recycling electronics that's growing. I really feel a sense of satisfaction out of that.

A life sentence has proven to be a death sentence. It's political. When lifer Reginald McFadden got out in 1994 and then raped and murdered several people, everybody got convicted of murder again with him, and the door slammed shut tight. Hope is in the air for the lifers now, especially with these juvenile lifers getting paroled. We're asking that everybody have a shot at being paroled.

The governor and lieutenant governor are ready to let people out, talking about all the costs of incarceration and that we have to get these men out into stable jobs and housing. That's the stuff we've been saying all along. Let me out and put me in charge of reentry, and I will really show you something! Instead of writing letters of support for me, people on the outside need to say, "We need him out here because we're trying to fulfill his vision."

Faith is still my foundation and it plays a part in most men who improve. You have to get your soul right, your intentions. The Holy Koran tells you how to live where you are, anywhere on the planet. Graterford is the place where I live, and I had the opportunity to follow that faith all these years. It was choice. I'm going to be the same on the outside, if I have that opportunity.

The young guys are starving for people like me, old heads to tell them something and give guidance. I get my opportunities to do it through Jummah (Friday religious services) and other programs that we have. You got to have some compassion for them. In our reintegration program, with the self-help perspective, we teach that we have to be responsible for ourselves. We tell guys that we got help for them, but they have to complete the prescriptive programs that the prison administration has for them. A guy will ease up to me and say, "I was supposed to get in a drug treatment program but I'm not a drug addict. Why do I have to

go through that?" And I say, "Go through it and learn something, as if you had a problem with it. You had some kind of problem. Take what you can from it." A couple of guys who were like that haven't been back. It is rewarding.

When I die, I'm going to be buried with this letter that a young guy dropped in my cell ten years ago. He talked about how I was a father to him, the father he didn't have. I was like "Wow! I didn't know that."

I'm writing my story and titled it *Discovering My Reason for Being*. Some people could be in this environment under the same circumstance I'm under and be in a living hell every day because they don't understand the purpose of life. I found a true sense of who I really am. I want to go out being a good human person, a believer in God and humanity, and helping people.

If you had known me before I came here and then talked to me now, you'd swear I was not the same person. I've come to learn that the real human person is the mind. I was feeling bad about myself inside. I was in a prison of my own mind because I didn't understand the concept of what a real man is. I changed my mind and refused to carry the idea that I'm different, inferior, and need to feel bad about myself. That was a waste of time. Now, I feel good about myself, have pride. I've become true to my purpose.

Cyd
Berger

*If you let your crime define you,
you will never see your potential*

Early 1990s

When I came here, I was in a cocoon. Since that time, I've evolved. I'm a butterfly now, and I'm ready to fly away. I think I have a lot to offer the world, and I've made a commitment to myself that if I get out, I'm going to do just that.

I didn't always have as clear a sense of who I am as I do now. When I was out, I was hung up on pleasing everyone, and I tried to live out their expectations. I lived for everyone except Cyd. When I came to prison, I learned how to love me and how to care about myself. Now I can go further and help others. If I make mistakes, I let them be my mistakes. I like who I am now. I didn't like myself very much before.

Just because you're in prison doesn't mean you have to be hard and cold. Sometimes the smallest thing like a smile or a word of concern can lift someone so high. I refuse to let this place make me afraid to be human. I refuse to walk around here with my head hung down, and I refuse to let authority strip me of my pride and my dignity and my sense of who I am. I may be an inmate, a prisoner, whatever label you choose, but I am a person first.

I was a "stuffer," and I'm still not a person who will cry on people's shoulders. I bottle stuff up inside. But when I need relief, I go to the place where I don't have to worry about what I say. I go to God. I pray about it. I can cry in front of God; I can be naked to the world, and God will care and not judge me if I cry.

Women lifers are like an invisible entity. It's like no one knows we're here. You read all the time about the men lifers—their graduations, the things they have. When we graduate, it's not in the papers. We're here, but no one really knows we are here.

There are so many victims. The person who it happened to is the victim, our families and children are victims, and in reality we're victims, too. There are a lot of talented, beautiful women in here who are going to waste. I believe deep down in my soul that with all our experience and influence, you have right here in prison what might help our next generation.

I've missed seeing my kids grow up, going to their baseball games. It's simple things like taking a bath or opening up my own refrigerator—being spontaneous—that I miss.

After I came to where I felt comfortable with Cyd, I reached out. Sometimes I

go against the grain, and hug and hold and touch and let people know that someone cares. I didn't leave my feelings at the gatehouse when I came here.

Whatever life brings, I want to take it head-on, to embrace it, to disclose its mysteries. I want to do all those things with life even in here.

2017

I made a promise to myself that every year I was going to add one new thing that I haven't done before. I set goals for myself and I don't look at my time. I look more at what I have done, because if you think about how long you've been here, it can begin to warp your mind. Thinking about accomplishments is better.

I've been raising dogs for fifteen years. People think it's just training dogs, but I have learned so many lessons, like responsibility and self-discipline, because I have to be consistent with the dog. It's like taking care of another person. You're not only responsible for yourself. Some have become service dogs, some are home companions. A lot of the staff here have adopted the dogs we've trained. We get stories of how they've made people so independent. They take a little piece of your heart, but you have to remember they are not our dogs. It is one of the best things I've ever done.

I just went up for commutation. I keep going up for it because if I don't fight for myself, who will? I've always had hope, but I think that things are going to get better for us. Eventually they are going to see that the cost to keep us here is ridiculous. They'll quit looking at us as a group and look at us truly as individuals, because not all lifers are bad. They need to ask, "Is this the same person who did this forty years ago?" Unfortunately, very few women go up for commutation because they are fearful and don't want to be told no.

I've heard it's hard out there, but regardless of how hard it is, I pray one day I get there! I've been good. I don't live with regrets—I've done that long enough. The last time I went up, the victim's family was still very angry. I've written them letters for the Inmate Apology Bank, but there's not much more I can do. Forgiveness is a release, and if they choose to hold on, there's nothing I can do. The last time I went up for commutation, they said I never apologized, but what they don't understand is that I cannot write or reach out to them. I don't think anyone has ever told them that.

I was twenty-five years old when I came to prison thirty-seven years ago. Someone took me under her wing, showed me the ropes and how to do good time. The women coming in now don't want to hear it and have no respect. They want to do wild time and then leave. They stay locked up inside their minds, constantly battling and being mad at the world. They are bruised and hurting women, and they act out, holding

on to their pain. How do you move forward when you're still living in your past? They leave here and come back, leave and come back.

Part of you wishes it was you, because you know that you have reached that point in your life, where you've grown up, done everything you can do, and can go out in the world and be successful. But you also feel bad for them because they don't get it. They don't use the tools that they receive. It's so sad. They come in and tell you a story about why they came back and want you to feel sorry for them. What I want is for them to *get* it! Women who are doing life sentences are tired of watching them coming in and out of here. It's like, "We will save your bed!"

I live with a lot of older women and life-sentenced inmates. We all pretty much mesh together. The young people see us, and they're like, "What's wrong with them? Why are they so content with who they are?" We are at that point in our lives where we begin to be comfortable in our own skin. We're not giving up, we still want to go home. We're just okay with who we are, because we worked on becoming the women we are today. We have prioritized things that they have not. It wasn't always easy. You look in the mirror every day and you still know there's so much that needs to be fixed. I try every day to grow; I remain teachable.

Our pastor said that when adversity comes, run to it, because that's where you grow. If you want everything to be on a mountaintop constantly, you're stuck because it's comfortable, and you won't want to do the extra work to grow. She's right, because when I think things are at their worst and I'm at my weakest, I'm actually at my strongest.

At the end of the day, I roll back everything that I did through my day. Did I offend someone? Was I unkind? I try to fix everything that day. I don't bring yesterday into today. I don't bring my heavy load with me. I start every day anew. If I've hurt someone, I want to know so that I can apologize and know how I hurt them. I don't know what triggers people have, and I don't want to hurt them again.

There's no single description of an inmate because we are people. If I got out today, how would someone know I had been in prison, unless I told them? "Inmate" is a word that the prison system gives us, but that's not who we are. Your crime should not define who you are. If you let that define you, you will never see your potential.

John Frederick Nole

The meaning of life is to try
to live it to its fullest, regardless
of where you're at

Early 1990s

I went to prison in 1971. I've been in prison for twenty-six years. I was seventeen when I was arrested.

I was very rambunctious when I was seventeen, and I took a lot of things for granted. My life sentence didn't really hit me until a few years later. At first, I took every opportunity to run around and do things that young kids do, like play ball. I didn't care much about my case at the time. Law, education, all those things didn't matter.

But I began to see that I really needed to do something with my life, that I was a little more capable than I had given myself credit for. About four years after I came in, I started changing my life around. I started going to school and I passed my GED. That was significant; it was a milestone for me. It made me feel wonderful. It was the first opportunity I had to make my family proud of me. But more than that, it allowed me to see what I was capable of as an individual.

I didn't know that before because I was oriented into a lifestyle where nobody achieved much of anything. Sports weren't that grand of a thing, and we didn't constantly see people becoming lawyers and doctors. We looked up to nobody. We didn't have any heroes. Black history was almost nonexistent for us. I had to come to jail to learn about what Black people did in history.

I don't know if I had any self-esteem on the street. I did things mostly according to what the group of kids that I hung around with did. I never tried to differentiate myself from them. I didn't say, "Freddie is an individual and I don't need to go and rob. I don't need to go and steal." None of that came into play. There was no real thought. There was no pausing to stop to try to rationalize what was right and what was wrong. My own sense of identity didn't exist on the street. That's probably why I got in trouble.

Then I got educated. Education has made me everything that I am today. It allowed me to see how wasteful and nonproductive the life was that I had in free society. If I could take those seventeen years of my life and throw them in the garbage disposal, I would not even refer back to it.

My education started with the old-time prisoners down at Graterford. You couldn't be around these people and not know things. All of them had struggled for every bit of freedom and independence they had.

Everything they did, regardless of how minor or how insignificant somebody else thought it might be, was significant to them. They took pride in their jobs, mopping hallways, cleaning clothes, shining their shoes, keeping their appearance together, staying healthy and strong—all these things mattered to them. There was no insignificance about their existence. And then there were guys telling me, "You are young, man. You are not going to do forever in here, you understand? Get your education. Learn whatever you can."

This is how my education started. This is when I started distinguishing myself from the people I had grown up with. By the time I was about twenty-five or twenty-six, I was chairman of the Lifers' Organization. I never stopped growing from that point on. Nobody ever made me feel that I wasn't capable of achieving something, even friends on the outside.

My lesson from all this is that if you want to change a person who's lived the kind of life I did, you have to remove them from the environment where they're not learning anything. One of the downfalls of all the different times that I was removed from society was being sent back into the same environment where there were not enough supportive mechanisms to keep old patterns from manifesting themselves. I had to start adapting once again to the lifestyle of the people that I associated with, even to the point that it was good to be dumb. Without any self-identity, you succumb to that.

This is the first time in my life when I have felt that if I am ever released, I have the understanding, I have the emotional stability, definitely the intelligence, to say, "No, that's not what I want to do."

I got married in 1984 when I was at Graterford. My wife was the first one who showed me that you can have rough times, you can have insecurity, and yet stay where you are! Another thing my wife has allowed me to experience is being able to say things like, "I'm sorry, I love you, I care about you." It was hard, but my wife made me understand there was nothing wrong with that.

I spend a lot of time analyzing my growth and development. I do it because I want to be of value when I get out of here. I don't want my life to always show that I've been here. I would like to be able to sit down with somebody and have a full conversation and then say, "Oh, by the way, I just got out of prison, you know." Let it be a surprise.

I don't want to treat people the way I've been treated since I've been here. Here you can't even be human. You can't make mistakes because you pay for them severely. In my twenty-six years here, I've paid for a lot of human things. You have anxieties, so you say to a guard, "Get the hell away from me." The next thing you know, you got a misconduct and you're spending thirty days in the hole.

In 1987, I received the Spirit of Philadelphia Award for the creation of the Parent-Child Resource Center. Then in '89 I was accused of grabbing a child in

there. Without having the opportunity of ever defending myself, I wound up here in Huntingdon.

There are things that I have really had to bounce back from on a number of occasions. But once again, my self-worth and who I am as a person have not allowed those things to overshadow and stop me from showing what I am capable of. I've been given the opportunity here at Huntingdon to basically regroup myself. To some extent I have been able to continue my advancement in the system—it's not been all in vain. But it's been a difficult six or seven years. You definitely got to wonder how long you can keep it up.

The only thing I regret about my prison experience is that I've been here so long and haven't been able to put a lot of things I've learned into motion in larger society.

2017

I've been incarcerated almost forty-eight years. I'm sixty-five. I'm getting ready to make parole under the juvenile lifers ruling.

I never thought I would die in prison. I've always prepared myself for being an asset in the community. I'm one of the more fortunate individuals who still has an external network. The adjustment period is definitely going to be there, but having a wife, kids, and grandchildren, sisters and brothers, I think I'll be alright. It's exciting—the anticipation, the excitement of just being out there, of being a husband to my wife, fully.

I haven't been able to overcome what happened to me in '89 and I had to actually confront a lot of anger issues as to what happened and the fact that it's still hanging over my head. I still prevail in my innocence. I have to fight against those lies with not only the administration but my peers, too. It's been humbling. I'm not as embraced for my knowledge and experience in programs as I once was, so I'm sidelined from being more involved in the creation of programs. This hasn't stopped me from doing the things that I do. I'm a worship leader in my church. I do work with People Advancing Reintegration. If I can feel productive and useful in any kind of way, then that makes up for a lot of the rough parts. You got a bad day, but you still pick up your sack and keep on heading down the road.

My motto is to maintain my consistency in what I do, my ideals, what I value. It makes it easy for people to identify my character, my mission, and what I'm trying to do. Maybe my first interview gave people the opportunity to see that when you come to prison, you don't have to get into that dark area of your life where it feels like people always owe you something. I think about President Kennedy: "Ask not what the country can do for you—ask what you can do for your country." The prison system is only obligated to keep me here. If I'm going

to better myself, it's like, "What can I do for myself and what can I do for the people who are around me?"

When I first came to prison, there was always the expectation that if you did well you would be rewarded for that. I think the prison system back then recognized the need to produce a better person, even a life-sentenced person, because you had more opportunities to develop and grow. Now, if you do good, it's seen as a game, like you're manipulating somebody with your antisocial, negative traits. Growing up and becoming a better person in prison is demonized rather than praised. That doesn't sit well with me.

Before, the prison administration consulted us about different things that affected our lives. They would call all the organizational heads together and talk to them about how certain things go, what they wanted to do, and how could it be done with their cooperation. Today, they really don't care or want our input. You just get a memo telling you what's going to happen, and nine times out of ten, there's a lot of chaos. The administration is not very trusting; they're not "people persons." And guards are there for security and that's all. I don't think that would make me feel good as a staff person, being on the front line and dealing with people every day, and having nothing to say about their rehabilitation, or what's good or bad.

The thing that keeps me going is the belief that somewhere along the line, good will prevail over evil. I get up every morning, find a new road to travel, and even if I have to travel the same road I traveled before, I still try to find something new and different in the way that I do it. Family and friends help me see the brighter side when things here get a little dim. It's a Michael Jordan thing: just do it.

The younger guys coming in lack respect. They come in angry, thinking that the system owes them something. They take no ownership of what they've done to get here and think the system and anything they offer is out to get them. It's like, "I don't owe you all nothin'! You all owe me everything."

The older guys don't want to deal with these younger guys because it's just too difficult—a hairy situation. There's fear and apprehension, because they're in gangs and if they don't comprehend what you say, it's like a diss. I might have a better relationship with some of the younger guys because of my religious involvement and consistency. I have a demeanor that tells them, "Look, if you are about to play games, keep it on the other side of the street. But if you sincerely want to know or work at something and be a little disciplined at what you do, then I'm all open for it."

The meaning of life is to try to live it to its fullest, regardless of where you're at. Find things of substance that help you fortify who you are as a person. Not being afraid to ask, to admit that you don't

know. Not being afraid to be vulnerable. I've found over the years, especially in my marriage, being vulnerable with someone helps educate and humble you. Maintaining a rigid diet of your ideal of humanity and justice, realizing that whatever might come our way has to be free of prejudice on either side. I don't take what happened to me and transport it onto someone else. I see them for who they are and where they're at in their lives. These are the things that make you a better person on all levels.

This is like the first fruit that I've ever had, and it's quite delicious

2021

In 2019, John Frederick Nole was released from prison, the result of Supreme Court decisions in 2012 and 2016 that ruled against mandatory life sentences for those sentenced as youth. In 2021, Barb and Howard reinterviewed him in his home, via Zoom. His wife, Sue, joined for part of the call.

Before I was incarcerated with a life sentence at seventeen years old, I had already been incarcerated a number of times. When you look at the total time that I spent under confinement, it's about fifty-five years. My life had simply been prison. Prison and now. Since I got out in January 2019, my life is like a brand-new book. You read one chapter, go to the next, and see how things continue. It's difficult to explain my gratification for where I am now.

When I got out, I ran into a couple of difficulties. I'm on parole for the rest of my life, so I couldn't live with my wife for six

months because the apartment complex didn't allow me to. I couldn't get a senior pass for public transportation because I didn't have a picture ID yet. I tried my jailhouse ID card to get the pass, exposing that I had been in prison. It didn't work. That just goes with getting out and thinking that the path is going to be smooth.

I didn't work for the first seven months because I had to make the transition out of here. But as soon as I went in for the job, it was like, "You're hired," because people had spoken up for me. I was never in fear of not being able to be employed. If I could work for the money that we made in prison, then I could do it in the street with no problem. I'd be glad to get up at five in the morning to go somewhere, to do a job for decent wages.

I got involved with Yokefellow Prison Ministry and the Delaware Valley Area Council. So, my activities are proving to be noteworthy. I spent a lot of time involved in the prison ministry while I was in prison, so it was very easy to come out and help people from the faith-based perspective.

They gave me a nine-month delay when I went up for parole. The counselor who had originally interviewed me for my parole processing never turned my information over, so there wasn't any record of me doing the programs that they required me to do. The parole board told me that I needed a life skills program. I had to sit there and remember all the things that I had told other people about dealing with the parole board. Don't get angry, don't try to show how disappointed you are. Be reasonable. I sat there for a minute, and said, "I don't want to argue with you all, but I've taught the program." Fortunately, my new counselor, who was more empathetic, found all of my records.

I could never get rid of that assault accusation from the Parent-Child Resource Center. When I made parole, I found out they had considered me a sex offender. There were no criminal charges. It was an institutional misconduct. They gave me time served in the hole. They didn't restrict me in any way. I even started a program to provide children's activities at the prison. I appealed and the parole board was eventually told that they assessed me wrong, and they removed restrictions about where I could go and who I could see. I'm now trying to shorten my parole to something less than lifetime parole.

When I think back on prison, I don't think about the regimentation, the guards being nasty, and all the other things that impacted my life. If I dwell on those things, I would transfer that to everybody out here in the free world. Do I think about prison in terms of the injustice that still prevails? Yes. I know how prevalent it is for people to die there without ever being given a chance. I know so many other people deserving of being out right now. Do I think that the system could do a better job in corrections? I

most certainly do, and that's the biggest takeaway.

All the lifers, especially all the juvenile lifers, who have come out have done well. They should be a resounding voice to the criminal justice system that life sentences are probably the most inhumane punishment that they can give a person. It is absurd and unjust that you can tell kids that their life is so meaningless that they'll never change and never be anything different than the crime they've committed.

Prison gave me the opportunity to find out who I was as a person, to grow up. To meet people who acted as mentors and showed me that prison wasn't the end-all. It's like you're running through all these tunnels. Somebody says to you one day, "If you want to get to the other side, you got to run through this tunnel. We can't tell you how long it's going to be, or where it's going to end up. But at the end, there's a door, and if you're fortunate enough to get there and open it, you won't even remember the world that you ran away from." The life sentence was just running through that tunnel. I had faith that I would never die in prison. But I also did all I could to get out or be prepared to get out and not get sucked into the dark hole of believing that I'm never getting out.

Prison scars you. But I had to realize that something needed to be restored in order for me move on. Sometime around '92, I started asking myself, "When I interacted with people and things got physical, what part might I have played in what that person said or how they responded to me?" With age and maturity, I realized how aggressive I had become and how much my attitude and the way I presented myself played a part in other people's attitudes. I changed the way I dealt with people and the way people dealt with me. I got into the habit of making conversation with officers differently, asking how they were doing. Not only did it make the guards feel better, but it actually made me feel better. The guard was no different than any person that needed a job. That was restorative justice for me: Did I have things in my life that needed to be restored? Could I truly see other people's positions besides how things affected me? How were other people affected by things that I might have done or said?

My support system, my wife, my friends never abandoned me. They always made me feel as though I had a purpose in their lives and outside of prison. My son always made me feel as though I was contributing to his life. Because of them, I have so much more appreciation for what might have been, had I been given a different course in life. The potential is still alive. I feel more capable than before I went to prison. All I want is to help people and use some of the tools I accumulated while I was in prison.

A good thing about being out is that I can get up in the morning and do whatever

I want. Just the normal, everyday things that you never thought about doing, and now you can do. I sit on the porch and take in the air. Make coffee for my wife, or breakfast. Lay in the bed a little longer if I want. If you want to go somewhere, you just go. It is a new way of living, a life that I didn't know I could have. If you have never been without it, then it's hard to imagine how it actually stimulates your psychological palate. For me, this is like the first fruit that I've ever had, and it's quite delicious.

Life Sentences: Trauma, Race, and Restorative Justice

Barb Toews

In the last twenty-five years, my life has been a successful spiritual journey. I've attained peace through self-disclosure, motivation, understanding, and living with integrity even inside a situation where it's 99.9 percent negative. I've accomplished things that have helped me become the best me.

—Kimerly Joynes

Life without the possibility of parole is about people with names like Harry Twiggs, Marie Scott, Gaye Morley, and Brian Wallace. Men and women with this sentence are real people with real lives before, during and, for the very few who are released, after incarceration. They all have unique and complex lived experiences—experiences that contributed to behavior that caused significant and fatal harm. Experiences that influenced who they are and what they do during their period of incarceration. Yet even with their differences, there is a common arc to their life stories as they have been told—stories of harm, victimization, and pain caused by people or social systems. They made the choice to transform and heal that harm and pain. They live active and purposeful lives and express accountability for the harm they caused. Their lives speak to the wonder of being human and our innate capacity to transform, find personal meaning, and be accountable, even in the face of great obstacles.

This is perhaps the most powerful lesson we can learn from the men and women here. This essay explores their journeys of healing and accountability through the lens of trauma, racialized trauma, trauma healing, and restorative justice. The exploration offers a way to understand life without the possibility of parole (from this point forward referred to as simply "life sentences"), its impact and consequences,

and the possibilities for a more humanizing and meaningful form of justice.

You are invited here to recognize and reflect on your own life and needs for healing and accountability, and even consider how that influences your perspectives on life sentences. You are encouraged to create space to learn about *your* life while learning about the lives of those with life sentences. Healing from harm and accountability for causing harm are not reserved for people who are incarcerated. They are universal to being human.

Trauma

Trauma is a common experience. Approximately 60 percent of men and 50 percent of women nationwide have experienced at least one traumatic event in their lives. For more than 60 percent of the U.S. population, the trauma experience occurred in childhood through what is known as adverse childhood experiences (ACEs), and 17 percent of adults have experienced *four or more* ACEs in their youth.[1] Even though only a small percentage (8 percent) of people will be diagnosed with post-traumatic stress disorder (PTSD), the prevalence of trauma suggests there is a good chance that you or someone you know has experienced at least one traumatic event.[2]

Sources of trauma are diverse. They can be interpersonal and directly experienced at the hands of other people, such as phys-ical, sexual, or emotional child abuse and neglect, sexual assault, intimate partner violence, and homicide. Trauma may be experienced when living in a household where an adult struggles with mental illness or an addiction, or when a parent is incarcerated. Some forms of trauma are more structural, such as racism, homelessness, and poverty. Even perpetrating violence, such as during military combat, can be experienced as traumatic and lead to PTSD symptoms. Whether it is of the variety stated above or in other forms, an event or experience becomes traumatic when the stress is so extreme that it overwhelms a person's ability to cope. Often, this stress stems from a real or perceived threat to their life. In these cases, the person experiences a physiological trauma response that, if left unhealed, can lead to aggression, violence, or other types of harmful behavior to oneself and others.

The body and brain are in charge of responding to threatening stimuli. When we are going about a normal day, our body and brain work together to allow us to do what we need to do without much effort required. When faced with a threatening or unsafe experience, however, the body kicks into high gear, releasing stress chemicals and hormones to fight or flee the situation. The body and brain focus on immediate survival and the parts of the brain that carry logic and moral frameworks—sometimes called the "thinking" brain—go quiet. If fighting or escaping is not possible,

> *Ask me how I got like that, man, I can't even explain it. Really, I think it comes from poverty . . . extreme poverty. When you grow up like this, the struggle takes all. You fight to eat; you fight to survive. I'm talking abject poverty. It takes from you the spirit. You have to crawl and fight, and it kills that spirit in you that makes you care about other people.*
>
> —Harry Twiggs

the body itself may shut down, rendering the person unable to talk, walk, or think, as a form of protection. Once the threat is gone, the body and the brain ideally return to their normal functioning.

In situations where the threat is unrelenting, however—for instance, in circumstances of physical abuse or poverty—the body sends out stress chemicals and hormones constantly, ensuring that the individual is always in survival mode, hypervigilant, and alert to threats. Epigenetics research, which explores how external influences in one's life can modify the way genes perform, raises questions about whether genetic modifications resulting from constant stress and trauma can be passed down to future generations.[3]

While we cannot always see with the naked eye the inner workings of the body and brain as they respond to threats, we can see and experience the outward con-sequences of it. People who usually appear calm and keep emotions to themselves may now express intense feelings uncontrollably. They may not remember things, including what happened to them, or they may be unable to recall events in a coherent way. They may not be able to make rational decisions for a period of time. Their relationships with other people may become rocky and conflictive. Perhaps most disconcerting, they may feel out of control and out of sorts, questioning the things they once took for granted, such as the meaning of life, a safe world, their identity, and their faith. People who have experienced traumatic events have a variety of needs, and some may not be able to identify what they require in a given moment. Safety is critical. Many need to talk about what happened and their feelings often, ask both practical and philosophical questions, and take back control of their lives. And, because they may

> *I lived in a prison in my own home with an abusive husband. When I first came to jail, it was a refuge: I didn't have to worry if he was going to kill me. But it didn't take long for the reality to set in.*
>
> —Diane Weaver

feel guilt and shame, many need vindication and assurance that they are not responsible for what happened to them.

Unfortunately, some trauma survivors do not have their needs met, leaving the trauma unaddressed or unhealed.[4] They may turn their trauma energy inward on themselves (acting in) or outward onto other people (acting out). "Acting in," a situation wherein trauma energy hurts oneself, can show up as depression, substance abuse, eating disorders, self-harm, or poor physical health. "Acting out," a situation wherein trauma energy is aimed toward others, can take the form of bullying, domestic violence, or child abuse. Acting out in this way lends credence to the common saying that "hurt people hurt people." Interestingly, acting in and acting out can be cyclical and simultaneous; a person may find themselves both experiencing harm and causing harm in an unending loop.[5] Overall, this cycle suggests that being hurt precedes harm-doing and that "trauma not transformed is often trauma transferred."[6]

Despite the potential for long-term physiological, behavioral, and relational impacts of trauma, there is great hope for healing. After exploring trauma within the context of the criminal justice system and racism, we will return to the journey of trauma healing later in this essay.

Trauma, Punishment, and the Criminal Justice System

Research as recent as 2019 shows that men and women who are incarcerated have experienced trauma and are diagnosed with PTSD at higher rates than their peers in the community.[7] We can then feel confident that lifers also have trauma histories. This preexisting trauma, however, is compounded by the incarceration experience, which itself is inherently traumatic. Therefore, in order to understand the relationship between trauma and life sentences, we must also comprehend trauma's relationship to criminal law, punishment, and justice.

Many indicators of trauma and the cycle of harming oneself and others have been codified into law as "crime," or otherwise bring the individual under the scrutiny of law enforcement and other actors in the criminal justice system. While some examples of this are obvious—for instance, assaulting or killing someone is considered a violent crime—others are less so. Jails, for example, have become de facto mental health facilities for people who struggle with mental illness or substance abuse. People who engage in survival sex and prostitution are constantly at risk of arrest. Each of these "crimes" may be indicators that the individual is dealing with trauma. These findings invite us to consider whether jails and prisons have become mere holding cells for people who are experiencing unaddressed and unhealed trauma.

To consider harmful behaviors through a trauma lens opens the door to reconsider what "justice" means and how to achieve it. If hurt people hurt people, it would make sense for justice to address both the pain experienced by the person who was victimized, and the hurt experienced by the person who harmed another.[8] This is not the case in the U.S. criminal justice system, however. The go-to response is to punish and subjugate the aggressor. On the surface, punishment may seem reasonable because Western society has come to believe that this is the natural outcome of any transgression, big or small.

Punishment permeates daily life; it shows up in how we parent children, deal with misbehavior in schools, and respond to violations at work. A deeper look suggests this punitive orientation has flaws. Punishment is largely about righting the scales of justice through pain, suffering, and revenge. You hurt me, so I am going to hurt you. It shows little to no regard for the experiences or conditions that give rise to harmful behavior. Taking these into account is often misunderstood as excusing away behavior, rather than articulating the catalysts of behavior that need addressing. Further, punishment demonstrates little concern for the person who was harmed, the damage and loss they experienced, or their needs to feel that they have received justice and that the damages have been repaired. Accountability on the part of the person who harmed them is unlikely. Punishment does not create the relational, emotional, or physical conditions in which an individual can safely seek to understand the harms he or she has caused and take meaningful steps for repair.[9]

With more than 1.5 million men and women in state and federal prisons, it is evident that incarceration is the national punishment of choice. The experience of incarceration can, and should, be understood through a trauma lens as well.[10] The criminal justice system in its current iteration strips men and women of their identity and humanity, identifying them by an administratively issued number and reducing them to labels such as "inmate" and "prisoner." Their lives are under significant control and

surveillance, and they are afforded few opportunities for personal choice or autonomy. They are surrounded by violence, or the threat of violence, from both those with whom they are incarcerated and those hired to oversee or provide various programs for them. They are cut off from supportive social networks.

These defining features of incarceration may push an individual into cycles of acting in and acting out within an institutional context. This may be expressed, for instance, through feelings of victimization at the hands of the criminal justice system, anger about their sentence and at the world, and aggressive or risky behavior.

Incarceration is not traumatic for all. For some, incarceration is similar to life "on the street." This reality does not negate the pains of incarceration; rather it speaks to that of their lives in the community, which they may or may not recognize as traumatic. Others may have coping strategies that allow threats presented by incarceration to feel more like stress than trauma. For most, however, incarceration adds to one's pain without acknowledging traumatic sources of harm-doing or creating conditions for meaningful accountability.

For the approximately 55,000 men and women serving life without the possibility of parole, the lived reality of incarceration diverges radically from that of other incarcerated men and women.[11] While those with less extreme sentences know that many years into the future they will leave prison, men and women without the option of parole are essentially stripped of all hope of release. This loss of hope is devastating, and the language they use to define it captures their despair: A life sentence is like a "black hole of pain and anxiety" (Cyd Berger) which "sucks everything in" (Bruce Bainbridge). It is "total darkness and you don't know whether the light is going to shine through" (Yvonne Cloud). Or, as Marie Scott and Aaron Fox explain, it feels like a "slow death" or "a death sentence without an execution date."

In prison, you have to always be cautious and consider violence as a possibility. You're dealing with some people who are very kind and patient, and some who are very mean and can get ugly at times. You hope for the best but you expect the worst.

—Kevin Mines

Lifers face a *lifelong* threat to their identity, which puts them in a constant struggle to retain their humanity and search for meaning in their lives. For some, a life sentence shatters most, if not all, of what they believed to be true about the world, such as opportunities for second chances and redemption. A life sentence is a deep wound to the very humanity of the men and women who live with these sentences. While the individuals in this book demonstrate that they are healed or healing from this and previous wounds, and accept responsibility for the harm they caused, it is not without first overcoming significant and counterproductive barriers inherent to the incarceration experience.

Racialized Trauma and the Criminal Justice System

Racism is a form of trauma that is particularly salient in the context of the criminal justice system, mass incarceration, and the proliferation of life sentences. Racialized trauma compounds the trauma experienced in the community prior to incarceration and that which is experienced in prison with a life sentence. While the impact of racialized trauma is most detrimental to the lives of lifers who are Black, Indigenous, and people of color (BIPOC), white lifers are not immune to its consequences.

From the time the first white settlers came to what is now called the United States, Black, Indigenous, and other people of color have been murdered, raped, enslaved, denied basic human rights, disenfranchised, and structurally and systematically placed in positions inferior to white people. Criminal law and law enforcement supported and facilitated these and other acts of violence to ensure that perpetrators were not held accountable.[12] Neither the Thirteenth Amendment in 1864 nor the Civil Rights Act of 1964 were intended actually to restructure society so it would be safe, equitable, and just for BIPOC citizens. Rather, they simply shifted the expression of racism away from the overt practices of slavery, lynching, and segregation and toward what Michelle Alexander calls "the new Jim Crow."[13] Racism is now covertly expressed through public policy and social institutions such as education, health, social and child welfare, economics, and the labor market.

This is perhaps most evident in crime and punishment policy, with mass incarceration serving as the primary tool through which segregation occurs.[14] Because laws may no longer blatantly target people of color, they are written to be racially neutral. Yet, in practice, the enactment of the law disproportionately impacts BIPOC community members. A classic example is the extreme sentencing disparity between crack and powder cocaine, where possession of crack, which was predominantly sold outdoors in Black and African American communities, carried harsher penalties than possession of powder cocaine, predominantly sold

> *I had real low self-esteem because of my complexion being dark. I thought I was ugly, and this made me mad and angry. I had pain in me, and when a person feels pain inside, they want to make somebody else hurt. You don't give a damn. I think I'm worthless and no good. Because I feel like that, I'm walking around with an arrogant attitude. I don't have nothing, so I don't like you or America because you got something. So therefore, I am going to hurt you.*
>
> —Harry Twiggs

indoors in white communities. Law enforcement officers targeted African American men, at least in part because street transactions were visible, thus shepherding an increasing number of African Americans into the justice system.[15] Thankfully, the 2010 Fair Sentencing Act reduced the sentencing disparities to some degree.

Fatal violence at the hands of law enforcement cannot be ignored. Native American, Black, and Hispanic/Latinx people are more likely to be killed by police than white people, prompting "the talk" that many Black and Brown parents give their children about how to survive an encounter with police.[16] And police officers are often protected by qualified immunity, making it possible for them to avoid charges, conviction, or accountability for overaggressive and fatal policing and brutality. Like other social systems, the criminal justice system is designed to ensure the primacy and safety of white people and their interests, while systematically harming and marginalizing BIPOC people.

The targeting of communities of color by law and law enforcement, as well as race-based disparities in conviction and sentencing, have contributed to the disproportionate incarceration of BIPOC community members.[17] Of the 1.4 million people incarcerated in state prisons, 38 percent are African American and 21 percent Hispanic, even though these groups constitute only 13 percent and 17 percent of the U.S. population, respectively.[18] Indigenous people are

incarcerated at four times the rate of white individuals.[19] Lifers are also disproportionately African American, and an African American youth is significantly more likely to receive life without the possibility of parole for killing a white person than a white youth is for killing a Black person.[20]

Prisons, as communities in and of themselves, are not immune to racism. Tensions may be exacerbated by the racial segregation that occurs, often with intention, within the prison, the results of which may return to the community.[21] Further, a prison may have a disproportionate number of white correctional staff in comparison to the proportion of incarcerated people of color,[22] mimicking the power imbalances in the outside community. An additional complicating factor is individual prejudice and bias.[23] The women and men who are incarcerated, as well as those who work in the system, all bring their own life experiences and perspectives about race into the prison community, acting and interacting through the lens of their own biases and prejudices.

Lifers who are BIPOC may experience little relief from compounding impacts of racialized trauma. They experience trauma in the community, then at the hands of the criminal justice system, and then within daily life in prison. They may also carry with them the intergenerational and historical traumas experienced by their ancestors. The experience of racialized trauma based on the color of one's skin, and the need to address it on a daily basis, does not disap-

pear. Should a lifer be released from prison, structural racism continues through legal barriers to employment, housing, public benefits, and education. While these barriers are faced by all incarcerated people regardless of race or sentence length, they may be particularly challenging for lifers of color, who face a range of racialized disadvantage.

Addressing racialized trauma is not just a matter of concern for lifers of color. Trauma experts suggest that the oppression and violence committed against people of color by white people may be a form of "acting out" from the trauma and persecution experienced in Europe that caused them to flee. And, because the perpetration of violence can be experienced as trauma, the impact of generations of harming and oppressing other people may be carried in their genes.[24] Lifers who are white may carry such trauma themselves and act it out in ways that intentionally or unintentionally exacerbate racial segregation and tensions in the prison. They may also be profoundly impacted by being forced into an environment rife with racial tension.

Just as trauma may be genetically transferred across generations, resilience may be similarly transferred. For centuries, people of color have persisted, resisted, and fostered perseverance and pride in their communities, even in the face of physical, emotional, social, and racialized trauma and racism. Healing from racialized trauma is indeed possible and is visible in the lives of BIPOC

and white community members.[15] Men and women in this book demonstrate a drive to heal from racialized trauma, despite the environment they are in.

Trauma Healing and Restorative Justice

Trauma, including racialized trauma, is a profoundly wounding experience regardless of whether one is incarcerated or free, and those wounds can show up in how we treat ourselves and other people. The drive to punish harmful behaviors, both minor and significant, turns a blind eye to the potential traumatic source of those behaviors, including racism. A punitive approach does not create the conditions necessary to nurture accountability. Punishment, especially incarceration, infects the wound, rather than heals it.

Healing from trauma is a profound experience for the many people who find themselves on such a journey. Experts in trauma and the paths to transform it indicate that trauma healing is marked by safety, acknowledgment, and reconnection.[26]

Safety is a prerequisite for any healing work: the body and brain need to get out of survival mode, and the individual needs to break free from the acting in/acting out cycle. Safety comes in many forms—physical, emotional, relational, and psychological. Once safe, many individuals seek *acknowledgment* of what happened to them. This can take the form of talking or creatively communicating about their experiences, expressing emotions, asking questions, and seeking vindication. The goal is to understand, grieve, and memorialize what was done to them and the loss they experienced. And, because of the acting in/acting out cycle, healing comes through the recognition of the harm they have done to themselves and others. This engagement in acknowledgment requires strength and vulnerability, which pays off in the form of meaning and purpose as they continue to heal.

Critical to healing is *reconnection* with oneself and rebuilding existing relationships or finding a new community. It is through this reconnection that individuals can envision new ways of living and being in the world, thus integrating their trauma experience into a new identity. Reconnection also seeks to create the conditions in which an individual can explore accountability *from* the people or systems that harmed them, and *to* the people they hurt. Accountability in this case includes understanding the losses and damages caused, and taking meaningful steps to repair them. Similar to acknowledgment, reconnection honors how people may have been both an aggressor and a victim.[27]

If punishment does not create the conditions for someone to embark on this healing journey, it is necessary to explore responses that do. One such approach is restorative justice, which seeks to identify the dam-

I didn't take the shape of my environment,
I pray that I didn't. I am still able to rise above. There is
the strength of a weed that grows up from the cement;
it's a weed but it's growing strong. I think of myself that
way. A lot of weakness comes from not feeling good
about yourself. I have enough self-esteem about myself
to know who I am. I'm a mother, a grandmother,
a great grandmother.

—Betty Heron

ages and needs resulting from harm, and to create the space and connections necessary for the responsible person to be accountable for those losses and to repair them in a meaningful way. This approach also seeks to identify the root sources of the aggressive and harmful behavior. Rather than a foundation of pain and punishment, restorative justice embodies and values respect, interconnectedness, and a belief in the possibility of transformation and healing for all.[28]

The most common way of doing restorative justice, but not the only way, is through face-to-face dialogue involving the harmed individual, the responsible person, and, in some practices, members of their communities. The benefits of such dialogues are clear. Participants better understand the impact of their actions, express remorse for them, and are more likely to complete agreements

for repair. Harmed individuals experience reduced trauma symptoms and greater satisfaction with the process and outcomes than with more punitive approaches.[29]

The men and women in this book demonstrate that they are actively, if not innately, drawn toward trauma healing and restorative justice. Despite the ongoing assault on their humanity and conditions meant to destroy them, they "rise above the walls"[30] in order to set foot on the healing path, finding safety and exploring acknowledgment and reconnection.

Many lifers speak to the source of *safety* they needed to take the first step on the healing path. They found it in their faith, crediting that with instilling calm and the ability to get through their sentence. Others looked to relationships and community, associating with older lifers who lived

There are some positive individuals in here,
some really empowering individuals . . . smart
individuals, caring individuals who could be good
role models and leaders in society. They are leaders
of organizations in here. Most of them are lifers.
These are guys that take time to reach back and pull
somebody in and say, "Look, you can do better." . . .
They saw me, the quiet guy, and said, "We ought to talk
to him and get him involved." They approached me and
that's how it started. Now I've got to remember what
they did for me and pass on the dollar.

—Ricardo Mercado

with a positive attitude that they admired, or to joining programs and organizations where they could find "their people." Mindfulness, through meditation and yoga, and even working with animals, calmed and imparted reflection and strength in themselves and in others. A solid grounding in what one values also provides safety; the lifers here speak of their commitment to service, peace, and justice, and embody those values in all that they do. These efforts create the "inner space, a heart space, a wisdom space,"[31] in the words of Carolyn Yoder, needed to bring the necessary strength and vulnerability to the work of healing and transformation.

The lifers in this book show evidence of *acknowledging* painful experiences in their lives and offer insights into the source of the violence that lead to their conviction and incarceration—from low self-esteem (including that which stems from racism), to not having an individual identity, to seeking an escape from abuse—and coming to grips with those sources so they can move forward with their lives. They describe their experiences with each other, counselors, and even the farm animals. Not all acknowledgment is in the form of talk—James Taylor is writing a book about his life for his grandkids. Marie Scott, Marilyn Dobrolenski, and Joseph Miller are artists,

and Craig Datesman is a musician. Many have a deep faith, and their prayers can also create the space for acknowledgment and grieving.

The lifers in this book speak loudly about *reconnection* with themselves. They "find themselves" in ways that restore self-worth; uncover new skills, interests, and gifts; and shine a light on their full human potential. They forgive themselves for what they have done and take advantage of opportunities to grow and learn.

Their lives are also relational in significant ways. They create community within the prison, among themselves as lifers and with other kindred spirits. They participate in educational, therapeutic, and service programs and peer organizations. They also value and nurture relationships with people outside the prison walls, especially their families. Many speak of the harm they caused their parents, children, and grandchildren and their efforts to rebuild and maintain those relationships. And, even though the younger generation of men and women can be a nuisance, they do their best to coexist with them, if not mentor them to instill the values and skills for safe and healthy communities inside and outside prison.

Reconnection also entails addressing the people and relationships impacted by their actions, especially those most directly victimized by it. Many of the lifers here express an acknowledgment of the damage they caused and a desire to face the people they hurt. Though they were not explicitly asked about the victims of the violence they committed, many spontaneously brought them up, expressing their regret and desire to somehow give back or make things right. Craig Datesman, the only lifer in this book who participated in a victim-offender dialogue, gives voice to the power of this process. He is not alone, however, in the desire of many lifers to engage with the people they have victimized.

Meaningful accountability in the case of fatal violence is difficult to conceptualize because a deceased person cannot be brought back to life. Loved ones left behind know this better than anyone. Yet accountability is possible to some degree through the acknowledgment of responsibility for the violence, an understanding of the harm caused, taking steps to ensure the violence will not happen again, and paying it forward by helping others.[32]

Helping others is a central theme across all the men and women represented. They have committed to giving back in endless ways: working with young men and women, volunteering in hospice and as Certified Peer Specialists, training service dogs, providing leadership for peer organizations, and developing and running reentry and restorative justice programs. Through acts of service, many find hope, meaning, and a purpose to their lives. In-prison programs that help sensitize participants to what it means to be victimized or introduce restorative justice have been especially rewarding

and healing for the incarcerated participants and others from the community. These programs, unintentionally or by design, also invite participants to explore the meaning of restorative justice and accountability for the harms they have experienced at the hands of others; for some, this may be their first time engaging in such reflection.

Over the past twenty-five-plus years, these lifers have shown that trauma transformed is healing transferred.[33] They have taken steps to pass on healing to those around them, even while living with a conviction, sentence, and environment antithetical to healing. Their journeys influence not only other incarcerated individuals but also those employed by the prison; their healing transforms the correctional community as a whole. It also extends outside the prison walls. They become what is known as "wounded healers," using their experience with trauma and adversity to continue to grow and assist others.[34]

Doing Justice Differently

The exploration of trauma, including racialized trauma, restorative justice, and trauma healing, invites us to examine critically the role of life sentences in criminal justice policy and offers insight into how to do justice differently. If trauma is connected to aggression and violence, does it make sense to inflict a lifetime of pain and suffering to teach those who cause harm that hurting people is wrong? If the process of trauma healing offers a way to interrupt the cycle of harming oneself and others, and to create space for a justice process that better addresses harms and nurturing accountability, could justice be oriented around trauma transformation instead? Can a justice process oriented toward trauma healing and restorative justice address racism that undergirds society and fuels the criminal justice system? These are challenging questions, especially given our societal penchant for pain, punishment, and revenge. The portraits in this book help make the case that trauma healing and restorative justice offer us a path worth considering.

Critics who advocate for the abolition of life sentences without the possibility of parole often cite the high financial cost of incarcerating a human being for their entire life, coupled with low rate of return on public safety. They also cite the disproportionate impact on people of color. Some propose a maximum sentence of twenty years accompanied by substantive reentry programs, except in highly unusual cases. Others, including U.S. senator Cory Booker, call for a "second look" after ten years of incarceration, where a judge considers whether the original sentence should be modified based on a collection of factors.[35] Many argue that the money saved by not using life sentences could be diverted to social services to address community needs, including substance abuse treatment, mental health services, and economic programs.[36]

The meeting with the victim's family, telling her what actually happened, was the best thing in my whole incarceration. She told me what the loss meant to her and was understanding of what it's done to me, and how I've changed and grown. It's rewarding to know that, even after 35 years, they aren't hating you, being vindictive or wishing you were dead.

—Craig Datesman

States are already implementing such recommendations. For instance, the state of Maryland, through the Juvenile Restoration Act (SB494), is close to banning life without the possibility of parole for youth.[37]

Abolishing life without the possibility of parole and reducing the length of maximum sentences is not enough, however. Such proposals neither address the role trauma may play as a root cause of violence, nor the traumatic foundation of the very experience of incarceration. Racialized trauma remains ignored, as do the people who are harmed by violence and any potential for meaningful accountability. The length of punishment time changes but not the foundation that supports that punishment; its limitations and flaws remain intact.

A critical but challenging first step is to shift how we understand harmful behavior and treat incarceration as a time to focus on trauma healing and accountability. At its most basic, such an orientation could include the facilitation of trauma healing programs designed for an individual to safely explore one's trauma history, its relationship to that individual's aggression or violence, and needs for healing. Likewise, restorative justice–oriented programs can facilitate an understanding of the impacts of harm-doing and teach strategies to explore accountability for the harm individuals have caused others. Opportunities for face-to-face dialogue can be offered and widely advertised inside the prison and in the community. Programs of this nature are already occurring in U.S. prisons; it is imperative that such programs be available to all, including those with long sentences and those who have caused significant harm.

Just offering trauma- and restorative justice-oriented programs, however, is not

> *The perception of people in society is that people in jail are all bad. They're dangerous. They need to be in there. What about people who have made amends, who are well worthy of a second chance?*
>
> —Brian Wallace

enough. These programs must be facilitated in such a way that the participant is not defined as an "offender" rather than as a human being capable both of causing harm and being victimized. Making this shift can be particularly challenging when considering those with life and long sentences who have caused what could be considered the ultimate violence of killing another person. Prison staff are known to express the opinion that these programs are a waste of time for lifers. While their achievement of personal transformation and accountability occurs despite being seen as just "prisoners" or "lifers," those with life sentences deserve respect for their whole humanity. This requires a massive worldview shift on the part of correctional administrators and other staff, program providers from the community, the wider community, and even men and women who themselves are incarcerated.

A trauma orientation also invites us to consider the conditions that facilitate or impede accountability and a trauma heal-ing journey. While a degree of healing can occur while incarcerated, it cannot be complete, given the dehumanizing and potentially traumatic correctional context. The most fundamental way to remove this barrier is to rethink our reliance on punishment and incarceration as the natural response to harm-doing and to replace pain and revenge with healing and accountability.

Making this change, albeit challenging to consider, would reduce the need for an individual who has committed harm to have to protect themself from the assault of incarceration. It would create the conditions in which they are more likely to open themselves up to the deeply personal and difficult work of healing. This is not just a philosophical shift; it is also an environmental one. What would an environment that facilitates accountability and trauma healing feel and look like? In response to this question, some suggest redesigning correctional spaces to be more restorative and therapeutic in design, as well as design-

ing survivor-oriented spaces to better meet survivors' needs.[38]

Taken together, abolishing life sentences without the possibility of parole and incorporating these trauma- and restorative justice–oriented worldviews offers a vision for responding to violence that better meets the needs of those responsible for it and, by extension, those victimized by it. We would do well to stop assuming that all violence survivors desire harsh, long, and life sentences for those who hurt them, if they desire incarceration at all. While some do, others do not.[39] We have not equipped community members with the vision or language to express a desire for something other than punishment in response to their pain, even if they internally feel a need for something different. They may not be aware of other more healing or restorative options available to them, if those options exist at all. Research is finding that survivors will take advantage of restorative justice opportunities when offered, even when they know that the person who hurt them will not be incarcerated but instead will engage in a comprehensive set of restorative justice programs.[40] Those who do articulate a desire for lengthy punishment may find themselves better served and less interested in life sentences if restorative justice is presented as one option for justice that they can choose from, and if their needs, including needs for safety, are met.

Meanwhile, the covert racism that exists in law and the enactment of law clearly needs to be made visible and eliminated. Such a process cannot be left to lawmakers or enforcers; rather, it depends on those most knowledgeable about how racism manifests and is experienced. Trauma and restorative justice orientations also invite us to consider the harm that racialized trauma has caused to BIPOC and their communities. A growing number of trauma and restorative justice practitioners have integrated racial justice into their practice, specializing in healing historic harms and using restorative justice to address racial and social injustices.

Trauma healing and restorative justice present us with a vision for a just and equitable society for all. What does such a society look like? Some argue that it does not include life without the possibility of parole or other extreme sentences. Others contend it does not include detention or incarceration of any kind or length.[41] Instead, they propose that harm-doers, including those who act violently, remain in the community to be supported toward healing and accountability. This suggests that the whole community is oriented toward healing and is motivated and equipped with skills to support its members toward accountability. Some present visions for a "restorative justice city" that seeks to end mass incarceration and reverse its negative impacts through food justice, economic justice, environmental justice, and an architectural infrastructure to support the work of equity and justice.[42] These

justice advocates demonstrate that we cannot limit our focus to simply those who do violence; we need to look at who we are as a society.

What began as learning from people with life sentences about new ways of doing justice has ended with considering what a just and equitable society could look like. As the authors of this book, we take a position highly critical of life sentences. Nevertheless, our goal is not to impose our perspective on you as a reader. We do have hopes, however.

We hope you will reflect on what trauma, trauma healing, and restorative justice mean in your life, both when you have harmed others and when others have harmed you.

We hope you will seek to create conditions for healing and accountability in your life and community, both for when people have acted out against others and when they have been victimized.

We hope you will explore your position in relation to your experiences with racism and racialized trauma and consider where healing and accountability are needed for you and others.

We hope you will reflect on what you can learn from your personal experiences about the limitations and consequences of life sentences without the possibility of parole.

We hope you will talk with others about what you have learned to contribute to the dialogue about life without the possibility of parole.

We are willing to take it upon ourselves to try to better the community so that others won't follow in our footsteps. I would like society to take a good look at human beings and know that changes can be made, that changes are made by a lot of human beings who are doing life. There are a lot of good people sitting in these penitentiaries who are needed outside.

—Commer Glass

Resources for Further Learning

Mass Incarceration and Life Sentences

Abolitionist Law Center (Pennsylvania-specific organization) www
.abolitionistlawcenter.org/our-work
/a-way-out-abolishing-death-by
-incarceration-in-pennsylvania/

Michelle Alexander, *The New Jim Crow: Mass Incarceration in the Age of Color-blindness* (The New Press, 2010)

Information about Sharon Wiggins (to whom *Still Doing Life* is dedicated) en.wikipedia.org/wiki/Sharon_Wiggins

Marc Mauer and Ashley Nellis, *The Meaning of Life: The Case for Abolishing Life Sentences* (The New Press, 2018)

Memorial page for Bruce Norris (who died before the publication of this book) www.mourningourlosses.org/memorials/bruce-norris

Move it Forward, Podcast by Amistad Law Project (www.amistadlaw.org/get-informed/move-it-forward-podcast)

National Association of Criminal Defense Lawyers (Second Look Legislation) www.nacdl.org/Document/SecondLook
SecondChanceNACDLModelSecond
LookLegis

The Sentencing Project (Campaign to End Life Sentences) www.sentencingproject.org/publications/campaign-end-life-imprisonment

Bryan Stevenson, *Just Mercy: A Story of Justice and Redemption* (Spiegel & Grau, 2014)

Suave, Podcast by Futuro Media Group (www.futuromediagroup.org/suave)

13th, Documentary by Ava DuVernay (www.avaduvernay.com/13th)

Youth Sentencing and Reentry Project (Pennsylvania-specific organization) https://ysrp.org/juvenile-life-without-parole-jlwop/

Trauma and Trauma Healing

Nadine Burke Harris, *The Deepest Well: Healing the Long-Term Effects of Childhood Adversity* (Mariner Books, 2019)

Judith Herman, *Trauma and Recovery: The Aftermath of Violence—From Domestic Abuse to Political Terror* (Basic Books, 2015)

STAR: Strategies for Trauma Awareness and Resilience (training organization) www.emu.edu/cjp/star/

Bessel van der Kolk, *The Body Keeps the Score: Brain, Mind, and Body in the Healing of Trauma* (Penguin Books, 2014)

Carolyn Yoder, *Little Book of Trauma Healing (revised and updated)* (Good Books, 2020)

Restorative Justice

Collective Justice (organization) www.collectivejusticenw.org

Common Justice (organization) www.commonjustice.org

Danielle Sered, *Until We Reckon: Violence, Mass Incarceration, and a Road to Repair* (The New Press, 2019)

Barb Toews, *Little Book of Restorative Justice for People in Prison* (Good Books, 2006)

Howard Zehr, *Changing Lenses: Restorative Justice for Our Times* (Herald Press, 2015)

Howard Zehr, *Little Book of Restorative Justice* (Good Books, 2015)

Howard Zehr, *Transcending: Reflections of Crime Victims* (Good Books, 2001)

Howard Zehr, Allen MacRae, Kay Pranis, and Lorraine Stutzman Amstutz, *The Big Book of Restorative Justice* (Good Books, 2015) (includes Zehr's *Little Book of Restorative Justice*)

Race and Racialized Trauma

Coming to the Table (organization) www.comingtothetable.org

Fania Davis, *Little Book of Race and Restorative Justice: Black Lives, Healing, and US Social Transformation* (Good Books, 2019)

Thomas DeWolf and Jodie Geddes, *Little Book of Racial Healing: Coming to the Table for Truth-Telling, Liberation, and Transformation* (Good Books, 2019)

David Anderson Hooker and Amy Potter Czajkowski, *Transforming Historical Harms* justpeaceumc.org/product/transforming-historical-harms-by-david-anderson-hooker-amy-potter-czajkowski/

Micah Johnson and Jeffrey Weisberg, *Little Book of Police Youth Dialogue: A Restorative Path Toward Justice* (Good Books, 2021)

Resmaa Menakem, *My Grandmother's Hands: Racialized Trauma and the Pathway to Mending Our Hearts and Bodies* (Central Recovery Press, 2017)

Acknowledgments

At this stage in my life—I am seventy-seven at time of publication—all this important material would never have been translated into a book if it had not been for Barb. Knowing the importance of the topic—and, in fact, having met and even worked with many of the people in the project—Barb agreed to take the lead in pulling the material together, doing initial edits of the interviews, and managing the project overall. Her name deserves to be first on the cover just as much as mine.

—*Howard Zehr*

We express our most heartfelt gratitude to the women and men who participated in this project and trusted us with their experiences, perspectives, and portraits. We do not take the trust lightly and hope that our respect for you shines through.

Thank you to the Pennsylvania Department of Corrections (PADOC) administrators who permitted Howard to meet with and photograph these men and women and to the staff who facilitated his entry into the prison, taking care of security clearances and gate memos to bring in equipment and scheduling interviews to accommodate prison schedules, room availability, and security requirements. We are also very grateful for Lance Couturier, former Chief of Psychological Services for PADOC, who encouraged Howard to follow up on *Doing Life*, helped him get access for this project, and participated in the interviews. We regret that he is not alive to see it come to fruition. We also appreciate the assistance provided by Ellen Melchiondo.

Thank you to colleagues who reviewed and provided feedback on the manuscript, especially the closing essay. Their critiques and affirmations were immensely helpful in making connections across the book's themes and clarifying and deepening the argument to end life sentences without the possibility of parole. These individuals include Martina Kartman, Satory Adams, Katie Mansfield, Jeff From, Ken Cruz, Janelle Hawes, and Sarah Boothe.

The portraits and the majority of interview material from the early 1990s originally appeared in *Doing Life*, published by Good Books, an imprint of Skyhorse Publishing, Inc. and we thank Skyhorse for permission to reprint these here. Some interviews include material that was drawn from the original transcripts and has not been previously published.

We thank the many people at The New Press who have made this book possible. We have special gratitude for Diane Wachtell, executive director, for her enthusiasm for this book and advocating for its publication. This book would not exist without her support. We greatly appreciate Rachel Vega-DeCesario, assistant editor, who shepherded the project from just before submission to publication, Kameel Mir who was assistant editor in the early stages of the project, and Maury Botton, senior managing editor, who carefully saw the book through all stages of production.. We value the work of the copy editor Lee Oglesby and her attention to details. We thank those who were involved in the design of the book, especially for the care with which they approached the portraits: Brian Mulligan for the interior design and layout, and Emily Mahon for the jacket.

Notes

Introduction

1. Marc Mauer and Ashley Nellis, *The Meaning of Life* (The New Press: New York, 2018), 13
2. Mauer and Nellis, *The Meaning of Life*, 15
3. Mauer and Nellis, *The Meaning of Life,* 9
4. Though this label can reduce people to a single identity, many with life sentences do not experience being called a "lifer" insulting. They will often self-identify as a "lifer" as a point of pride, given all that they are surviving in prison; Nellis, *No End in Sight.*

Craig Datesman

1. At most Pennsylvania prisons, there is a peer-led organization dedicated to the experiences and concerns of people with life sentences. We refer to them generally as a "Lifers' Organization," as there isn't one standard name for these organizations.
2. At the time of the 2017 interview, the men incarcerated at Graterford prison were anticipating a move to a new prison that was constructed on the Graterford grounds. They made the move to this prison, named Phoenix, in the summer of 2018.

Marie Scott

1. An honor cottage is a special housing unit in which people who have clean disciplinary records can choose to live. Many prisons have such housing units and provide a variety of perks for those who live in them, including fewer restrictions and more autonomy.

Life Sentences: Trauma, Race, and Restorative Justice

1. Nadine Burke Harris, *The Deepest Well* (Mariner Books: Boston, 2018); Centers for Disease Control and Prevention (CDC), "Preventing Adverse Childhood Experiences," www.cdv.gov

2. National Center for PTSD, "How Common is PTSD in Adults," www.ptsd .va.gov

3. Carolyn Yoder, *Little Book of Trauma Healing* (Good Books: New York, 2020); Thomas DeWolfe and Jodie Geddes, *Little Book of Racial Healing* (Good Books: New York, 2019); Bessel van der Kolk, *The Body Keeps the Score* (Penguin Books: New York, 2015); Burke Harris, *The Deepest Well*; Strategies for Trauma Awareness and Resilience (STAR), *Level 1 Workbook* (Center for Justice and Peace-building, Eastern Mennonite University, 2021); Centers for Disease Control and Prevention (CDC), "What is Epigenetics," www.cdc.gov

4. There is no agreement on what term to use when referring to people who have experienced harm at the hands of a person(s) or system. In this essay, I use the term "survivor" and variations of "person who has been harmed."

5. Yoder, *Little Book of Trauma Healing* STAR, *Level 1 Workbook*

6. Danielle Sered, *Until We Reckon: Violence, Mass Incarceration, and a Road to Repair* (The New Press, 2019); STAR, *Level 1 Workbook* (Paraphrase of Father Richard Rohr, Center for Action and Contemplation)

7. John Briere, Elisha Agee, and Anne Dietrich, "Cumulative Trauma and Current Posttraumatic Stress Disorder Status in General Population and Inmate Sample," *Psychological Trauma: Theory,* *Research, Practice and Policy* (2016): 439–446; Emma Facer-Irwin, Nigel Blackwood, Annie Bird, et al., "PTSD in Prison Settings: A Systematic Review and Meta-analysis of Comorbid Mental Disorders and Problematic Behaviors," *PLoS One*, 14, no. 9 (2019)

8. The trauma and restorative justice orientations invite us to see people who harm others as just that, people who harm others. The orientations also challenge us to remember that those who cause harm may also have experienced harm at the hands of another person(s) or system. This view holds even in cases of significant, violent, and fatal harm-doing. Labels such as "offender" or "inmate" are reductive and deny the harm-doer's humanity. As a result, I use language such as "people who cause harm" and "people who are incarcerated" instead of these labels. When I refer to "lifers," I am using a term generally considered respectful by men and women who are serving life sentences (see Nellis, *No End in Sight*).

9. Personal communication with Martina Kartman and Satory Adams of Collective Justice.

10. Yoder, *Little Book of Trauma Healing* STAR, *Level 1 Workbook*

11. Mauer and Nellis, *The Meaning of Life*, 13

12. For more on this history, see Fania Davis, *Little Book of Race and Restorative Justice* (Good Books, 2020); DeWolf and Geddes, *Little Book of Racial Healing*; Micah Johnson and Jeffrey Weisberg, *Little Book*

of Police Youth Dialogue (Good Books, 2021)

13. Michelle Alexander, *The New Jim Crow* (The New Press, 2010)

14. Alexander, *The New Jim Crow*

15. Alexander, *The New Jim Crow*; Katherine Beckett, Kris Nyrop, and Lori Pfingst, "Race, Drugs, and Policing: Understanding Disparities in Drug Delivery Arrests," *Criminology* 44, no. 1 (2006)

16. Elle Lett, Emmanuella Ngozi Asabor, Theodore Corbin, and Dowin Boatright, "Racial Inequity in Fatal US Police Shootings, 2015-2020," *Journal of Epidemiology and Community Health* (Oct. 2020)

17. The Sentencing Project, *Criminal Justice Facts*, www.sente ncingproject.org; Sentencing Project, *Facts about Prisons and People in Prison*, www.sentencingproject .org

18. Ashley Nellis (2016), *The Color of Justice: Racial and Ethnic Disparity in State Prisons*, www.sentencingproject.org; The Sentencing Project, *State-By-State Data*, www.sentencingproject.org

19. The Sentencing Project, "Race and Justice News: Native Americans in the Justice System," www.sentencingproject.org

20. Mauer and Nellis, *The Meaning of Life*, 103–104

21. Randol Contreras, "Standpoint Purgatorio," in *Violence at the Urban Margins*, ed. Javier Auyero, Philippe Bourgois, and Nancy Scheper-Hughes (Oxford Scholarship Online, 2015)

22. Federal Bureau of Prisons, "Staff Ethnic-ity/Race," www.bop.gov; Federal Bureau of Prisons, "Inmate Race," www.bop.gov

23. Davis, *Little Book of Race and Restorative Justice*

24. STAR, *Level 1 Workbook*; Resmaa Menakem, *My Grandmother's Hands: Racialized Trauma and the Pathway to Mending Our Hearts and Bodies* (Central Recovery Press, 2017)

25. Menakem, *My Grandmother's Hands*

26. The following sections draw from Yoder, *Little Book of Trauma Healing*; Judith Herman, *Trauma and Recovery* (Basic Books, 2015)

27. STAR, *Level 1 Workbook*; Yoder, *Little Book of Trauma Healing*; Herman, *Trauma and Recovery*

28. Howard Zehr, *Little Book of Restorative Justice* (Good Books, 2015); Barb Toews, *Little Book of Restorative Justice for People in Prison* (Good Books, 2006)

29. Mark Umbreit, Betty Vos, Robert Coates, and Katherine Brown, *Facing Violence* (Lynne Rienner Publishers, 2003); Lawrence Sherman and Heather Strang, *Restorative Justice: The Evidence* (Smith Institute, 2007); Caroline Angel, Lawrence Sherman, Heather Strang et al., "Short-term Effects of Restorative Justice Conferences on Post-traumatic Stress Symptoms among Robbery and Burglary Victims: A Randomized Controlled Trial," *Journal of Experimental Criminology,* 10, no. 3 (2014)

30. The Elsinore-Bennu Think Tank for Restorative Justice, *Life Sentences: Writings*

from Inside an American Prison (Belt Publishing, 2019)

31. Yoder, *Little Book of Trauma Healing*, 65

32. Howard Zehr, *Transcending: Reflections of Crime Victims* (Good Books: New York, 2001); Sered, *Until We Reckon*

33. Participants in the Horizon Prison Initiative (Ohio), personal communication with Jeff From

34. Yoder, *Little Book of Trauma Healing*

35. "Booker, Bass to Introduce Groundbreaking Bill to Give 'Second Look' to Those Behind Bars" July 2019, www.booker .senate.gov; Mauer and Nellis, *The Meaning of Life*; Nellis, *No End in Sight* (www .sentencingproject.org); JaneAnn Murray, Sean Hecker, Michael Skocpol, and Marissa Elkins, *Second Look=Second Chance: The NACDL Model "Second Look" Legislation* (National Association of Criminal Defense Lawyers, 2020, www.nacdl.org)

36. Mauer and Nellis, *Meaning of Life*

37. "Juvenile Restoration Act (HB409/ SB494)," Campaign for the Fair Sentencing of Youth, www.cfsy.org

38. Barb Toews, "Architecture and Restorative Justice: Designing with Values in Mind," T. Gavrielides (Ed.), *Routledge International Handbook of Restorative Justice* (Oxford: Routledge, 2018) 279-293

39. Tom Jackman, "Study: 1 in 7 U.S. Prisoners are Serving a Life Sentence," *Washington Post*, March 7, 2021, www .washingtonpost.com

40. Sered, *Until We Reckon*; Jackman, "Study: 1 in 7"

41. Mariame Kaba, *We Do This 'Til We Free Us: Abolitionist Organizing and Transforming Justice* (Haymarket Books, 2021)

42. Designing Justice+Designing Spaces, *Restorative Justice City*, www.designing justice.org

About the Authors

Howard Zehr is a distinguished professor of restorative justice at Eastern Mennonite University's Center for Justice and Peacebuilding. He is the author of the bestselling *The Little Book of Restorative Justice* and *Doing Life*, among other titles. He lives in Broadway, Virginia.

Barb Toews is associate professor of criminal justice at University of Washington Tacoma. She is the author of *The Little Book of Restorative Justice for People in Prison* and the coauthor, with Howard Zehr, of *Critical Issues in Restorative Justice*. Toews is the editor of the Little Books of Justice and Peacemaking series and lives in Tacoma, Washington.

Publishing in the Public Interest

Thank you for reading this book published by The New Press. The New Press is a nonprofit, public interest publisher. New Press books and authors play a crucial role in sparking conversations about the key political and social issues of our day.

We hope you enjoyed this book and that you will stay in touch with The New Press. Here are a few ways to stay up to date with our books, events, and the issues we cover:

- ❖ Sign up at www.thenewpress.com/subscribe to receive updates on New Press authors and issues and to be notified about local events

- ❖ Like us on Facebook: www.facebook.com/newpressbooks

- ❖ Follow us on Twitter: www.twitter.com/thenewpress

- ❖ Follow us on Instagram: www.instagram.com/thenewpress

Please consider buying New Press books for yourself; for friends and family; or to donate to schools, libraries, community centers, prison libraries, and other organizations involved with the issues our authors write about.

The New Press is a 501(c)(3) nonprofit organization. You can also support our work with a tax-deductible gift by visiting www.thenewpress.com /donate.